Design Essentials

Design Essentials
A HANDBOOK

SECOND EDITION

Gisele Atterberry
Illinois State University
Normal, Illinois

with

Jonathan Block
Right Hemisphere USA
Bellingham, Washington

Prentice Hall, Upper Saddle River, NJ 07458

Library of Congress Cataloging-in-Publication Data

Atterberry, Gisele
 Design essentials : a handbook / Gisele Atterberry, Jonathan Block—2nd ed.
 p. cm.
 Block's name appears first on earlier edition.
 Includes index.
 ISBN 0-13-502469-2
 1. Design Handbooks, manuals, etc. I. Block, Jonathan
II. Title.
 NK1510.B578 2000
 745.4—dc21 99-43242
 CIP

Editorial Director: Charlyce Jones Owen
Publisher: Bud Therien
Production Editor: Joe Scordato
Manufacturing Buyer: Lynn Pearlman
Formatter: Lori Clinton
Line Drawings: Elizabeth Fathauer
Editorial Assistant: Wendy Yurash
Cover Design: Jayne Conte

Cover Image: Elizabeth Murray "Painters Progress" (1981).
Oil on canvas in 19 parts, overall 9'8" × 7'9" (294.5 cm × 236.2 cm).
The Museum of Modern Art, New York. Acquired through
the Bernhill Fund and gift of Agnes Gund. Photograph
copyright 1999, the Museum of Modern Art, New York.

This book was set in 10.5/12 New Century Schoolbook
and was printed and bound by Courier Companies, Inc.
The cover was printed by Phoenix Color Corp.

Printed in the United States of America

10 9 8 7 6 5 4 3 2 1

ISBN 0-13-502469-2

Prentice-Hall International (UK) Limited, *London*
Prentice-Hall of Australia Pty. Limited, *Sydney*
Prentice-Hall Canada Inc., *Toronto*
Prentice-Hall Hispanoamericana, S.A., *Mexico*
Prentice-Hall of India Private Limited, *New Delhi*
Prentice-Hall of Japan, Inc., *Tokyo*
Pearson Education Asia Pte. Ltd., *Singapore*
Editora Prentice-Hall do Brasil, Ltda., *Rio de Janeiro*

Contents

Preface

Two-Dimensional Design, along with Beginning Drawing and Art History Survey, forms the foundation of most contemporary training in the visual arts. We seek in our courses to provide students with basic tools that will enable them to make the most of their continuing education in art and be of value to them regardless of their ultimate career. Therefore, the focus of our courses is on conceptual tools, rather than mechanical skills. Moreover, we seek to develop our students' awareness of the basic issues that they will be confronting throughout their creative lives and to equip them so that they will productively address the challenges that they surely will encounter.

In developing the revised edition of *Design Essentials,* we sought to create a tool that would be of equal benefit to those students planning careers in graphic design as well as those pursuing fine arts degrees. Clearly, a basic two-dimensional design course is indispensable for both, and further, the sharp distinctions that formerly existed between the two career paths are ebbing away today. We hope this book will be useful as a tool for all of our students, as well as to our colleagues (and ourselves) in teaching. There are many traditional texts organized around the elements and principles of design, but often we found ourselves presenting information in terms of conceptual or thematic issues. Frustrated by the necessarily linear and hierarchical presentation of material in more traditional texts, we sought a new organizational structure—but we soon realized that we were creating an alternative hierarchy. It was still a confining rather than a liberating structure.

At that point it occurred to us that what we really needed was simply a glossary. While the structure, order, and form of our courses have varied enormously over the years, the central content remains the same; we continue to develop the same range of awareness and skills in our students. What changes is the emphasis and methods of presentation. The alphabetical structure of a glossary of two-dimensional design allows us to put the essential information at our fingertips without imposing a specific conceptual structure upon us or our students. Further, as students encounter writing assignments in our courses or in other art classes, this illustrated glossary may aid them in finding verbal equivalents for visual expressions.

In selecting illustrations for the text we have limited

ourselves to modern and contemporary images. The text is intentionally nonhistorical in its organization and presentation. While we believe deeply in the value of history as a source and resource, design as the core of studio foundation courses is a contemporary idea. We feel design is best taught through the medium of recent images and ideas.

The text is intended to serve as a handbook that supports the teaching and programs with evolving or well-developed curricula. We assume that the instructor will use the information provided to reinforce an existing curriculum. At the beginning of the semester, we ask our students to read *College and Career* and *The Design Process,* and to skim through the glossary. The informa-

tion in the glossary is referred to regularly in assigning problems and in critiques. The shared references it provides, both verbal and visual, facilitate effective communication among all members of the class.

The glossary contains four general types of terms: those describing visual elements or design principles, those describing media or materials, those relating particularly to graphic design, and those describing critical ideas or historical styles and movements. We included the last in order to support historical references that are bound to be made in critiques and to encourage students' awareness of modern and contemporary art as central elements of the cultural context within which they work.

Acknowledgments

Our gratitude is first extended to Bud Therien, who guided us in the creation of the earlier edition of this book and whose influence remains strong here. Marion Gottlieb, our editor for this edition, supervised the revision process with unending patience. This second edition is fully in debt to her perception and sensitivity. Joe Scordato, our production editor, worked efficiently and tirelessly to transform the raw material of the manuscript into this book. His professionalism in all matters is deeply appreciated.

The diligence of Linda Sykes, photo research, and Irene Hess, photo permissions, deserves special recognition.

Elizabeth Fathauer, a former student and now a professional designer, responded whenever queried with sound advice. As with the first edition, her close cooperation and development of clear and effective illustrations were central to the project.

Brian Braye, Joanne Long, and Kay Stults of Illinois State University offered able assistance in a variety of technical matters.

Sincere gratitude is due to artists Karl Moehl and Don Lake for their wise counsel. We are also indebted to the following artists who aided our project in countless ways: Sheila Asbell Allen, Judith Baker, Jim Butler, John Ekstrom, Reverend Howard Finster and his daughter Beverly, Ray George, Gaylen Hansen, Ken Holder, Ron Jackson, Maurie Kerrigan, Vera Klement, Michael Nakoneczny, Kenny Scharf, Hollis Sigler, Chris Starkey, Lloyd Wassenaar, and Anna Marie Watkin.

Representatives of the following institutions were extremely generous with their time in guiding us in the selection of fine art illustrations: The Addison Gallery of American Art, The Art Institute of Chicago, The Arkansas Arts Center Foundation, The Baltimore Museum of Art, The Barber Institute of Fine Arts, The Cheekwood Museum of Art, The Fogg Art Museum, The Hirshhorn Museum and Sculpture Garden, The Jefferson Medical College, The Los Angeles County Museum of Art, The Menil Collection, The Montclair Art Museum, The Museum of Modern Art, The Museum of Fine Arts, Boston, The Metropolitan Museum of Art, The Montreal Museum of Fine Arts, Musée d'Orsay, Paris, Musée du Petit Palais, Geneva, The National Museum of American Art, Normal Editions Workshop at Illinois State University, The Philadelphia Museum of Art, The St. Louis Art

Museum, Sammulung Ernst Beyeler, The Walker Art Center, and The Whitney Museum of American Art.

Special thanks are due to Kathleen Jones of the Krannert Art Museum at the University of Illinois, Alina A. Pellicer of PaceWildenstein, Steven Sergiovanni of the Holly Solomon Gallery, Lisa Stone of the Roger Brown Study Collection, Ron Jagger of the Phyllis Kind Gallery, Kathy Henline of the Indiana University Museum of Art, Barbara J. Friedl of Landfall Press, Ann Boyd of Roy Boyd Gallery, Eva Belavsky of Maya Polsky Gallery, Anne K. Mersmann of the Santa Barbara Museum of Art, Melody Ennis of the Museum of Art at the Rhode Island School of Design, Fran Tell, Sheila Ferrari, and Mr. and Mrs. John Berggruen.

Finally, a collective bow of thanks goes to friends and family who continue to provide essential support and encouragement.

Gisele Atterberry
Jonathan Block

Design Essentials

CHAPTER ONE

The Design Process

de.sign *verb* to plan; to scheme; to intend for a definite purpose; to conceive; to think out considering the consequences and the interrelationships of sequential events

Design is an active process. When asked to form a picture in our minds of an artist or designer at work, we are inclined to visualize someone involved in painting, drawing, or sculpting. We think of the work of the artist or designer primarily as the manipulation of materials. In fact, a substantial amount of an artist's time is spent on the design process—thinking and looking. When confronted with a problem, an artist does not wait for inspiration, but rather applies the learned principles of design to develop appropriate strategies for meeting the visual challenge. When things are going well and ideas are flowing, this design activity may be carried out intuitively. When things get difficult, we call on our training.

The design process involves two major areas of challenge: generating ideas and realizing them. The first area

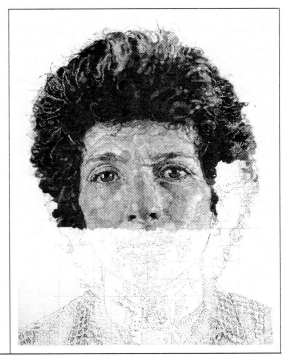

FIGURE 1 Chuck Close, *Phyllis*, 1984, work in progress, pulp, paper and collage on canvas, 8′ × 6′. Courtesy PaceWildenstein, New York. Photo by Zindman/Fremont.

is approached by developing skills of problem definition and ideation; the second by developing manual skills and abilities in analysis and judgment. In this section we will first consider sources for ideas, and then the creative process.

ORIGINALITY AND SOURCES

Beginning students sometimes feel that the greatest difficulty they face is generating ideas. This frustration can be the result of a limited understanding of the creative process and misconceptions about the idea of originality. Many bring to their creative work a false idea of the romantic muse and expect artists to be consumed with passion and somehow divinely or diabolically inspired. This misconception can result in a paralysis of "waiting for ideas," an artist's version of writer's block. Artists and designers are visual problem solvers. They cannot just wait for inspiration; they must use their eyes and minds to look for ideas.

Designers and artists have the whole world as a source book. Our ideas spring from experiences and our interpretations of them. They arise from what we have seen, read, felt, and heard. Original ideas result from the forming of new relationships and connections, enabling us to see and relate to the world in new ways. To produce original ideas we must avail ourselves of the widest possible range of knowledge and experience.

There are many rich sources of ideas. Foremost among these sources is the work of other artists. Artists always have drawn ideas from the work of their contemporaries and those who preceded them, as Pablo Picasso was inspired by the Northern Renaissance painter and printmaker Lucas Cranach the Elder (Figure 2). To deny yourself access to this vast resource is to attempt to work in a vacuum. When contemporary masters are asked to

FIGURE 2 Pablo Picasso, *David and Bathsheba*, second state, March 30, 1947. Lithograph, printed in black, composition: 25⅞″ × 19⅝″ (65.7 cm × 49.8 cm). The Museum of Modern Art, New York. Acquired through the Lillie P. Bliss Bequest. Photograph © 1999 The Museum of Modern Art, New York.

name those whose work has had a great influence upon them, they often mention the "old masters." Even the most radical work of today is firmly rooted in the past.

Have you ever looked at someone else's work and said to yourself, "I wish this idea were mine?" It can be. Just because someone else has expressed an idea, you are not precluded from pursuing the same idea, imbuing it with uniqueness in the specific ways in which you present it. If you see an idea in the work of someone else that you wish were your own, you should feel free to be inspired by it. In developing it, you will make it your own. This active exploration and development of the idea takes your translation beyond copying or plagiarism. Rather, it is in the highest tradition of artistic growth.

If you wish to understand the ways in which forms can be combined, you need only to look at and observe the world around you. Eyes can function as much more than radar to keep you from walking into walls. Vision need not be passive. It can be active, interpretive, and challenging.

For many, a most important resource is fellow artists. Other artists are able to look at our work from a different perspective. They can help us recognize potential problems and offer possible solutions. All too often, we do not gain valuable insights until critique time. Through discussion with others, these insights could have come much sooner. Do not wait until a critique to seek responses to your work. Ask your fellow students for their comments. Communication with your colleagues should be an ongoing process.

THE CREATIVE PROCESS

While it is sometimes true that new ideas seem to leap unexpectedly to the front of our consciousness, most often they result from a careful and thoughtful analysis of the problem at hand. Creative persons in all fields are interested in the methodology of creativity, and many models of the creative process have been put forward. One of the simplest and most useful (Figure 3) divides the process into several steps: acceptance, problem definition, ideation, judgment, realization, and analysis.

Two important items are important to note in this model. One is that ideation, the generation of ideas, does not come first. The second is that ideation is separate from judgment. If you can keep these two things in mind, you are well on your way to becoming an effective problem solver.

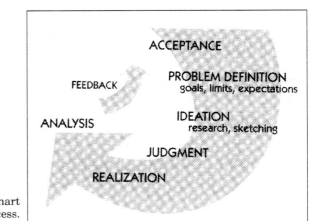

FIGURE 3 Flow chart of the creative process.

Acceptance

The first step in any creative problem-solving situation is to consciously accept the problem. This may seem unnecessary, but occasionally you may find yourself in the middle of a problem without ever having decided that you really want to solve it or without believing that it really is a problem in need of solution. Lacking any real desire to solve the problem, you direct your creative energies toward efforts to avoid or eliminate it. If you want to bring your creativity to bear, you must want to solve the problem. What is required is an active receptivity, a willingness to make the problem your own.

In class situations you may be confronted with an assignment that seems to have little relevance to your particular interests or goals. Rather than resisting or rejecting the problem, keep in mind the unique goals of the classroom situation. The class offers an opportunity to discover ideas, materials, or approaches that you might have been reluctant or unlikely to explore in other circumstances.

Mature artists often focus their attention on a narrow area of concerns, exploring in depth a limited problem. If you look at a survey of the life's work of an artist, you are likely to be struck not by the variety in his or her work, but by its unity. As a beginning student, however, you should expose yourself to the greatest variety of experiences and attitudes. It is at this stage of your growth that you build the visual and experimental vocabulary that you will draw from for the rest of your life. If you limit yourself now, you will have less at your disposal in the years to come. Be willing to approach problems with an open mind. While your assignments may not seem relevant to your immediate personal interests, your responses to them will provide valuable experiences.

Problem Definition

Accepting a problem is closely tied to defining it. To accept a problem, you must first understand what the problem is. Problem definition involves attempting to spell out as clearly as possible what you want to accomplish, taking care to make no false or unnecessary assumptions. Problem definition is the process of defining goals and establishing limits. Your definition of a problem determines the areas in which you will seek and find solutions.

Before beginning work on an assignment, it may be useful to ask the following questions.

- What are the goals of the exercise; what is it intended to accomplish?
- What are my goals; what do I hope to achieve through this exercise?
- What are the instructor's expectations?
- What are the exercise's limits in terms of scale, materials, methods of execution, presentation, time, and so on?
- Can I restate the problem in such a way that it incorporates all of these goals and limitations—the instructor's and my own?

At this point you are ready to proceed, keeping in mind that it is always possible, and often desirable, to return to this stage of the creative process. As your work proceeds, your understanding of the problem is likely to

change. This evolving understanding of the issues can result in a need to redefine the problem and reaffirm your acceptance of the challenge.

Only after honestly accepting and carefully defining the problem should you attempt to proceed. Many creative failures result from either a refusal to accept the problem or an improper understanding of it.

Ideation

This is the part of the process that is usually associated with intellectual creativity. At this point you come up with ideas and possible solutions to the problem. Your goal should be to generate as many different ideas as possible without screening them into categories of good or bad.

The most common mistake is to judge your ideas immediately, before taking time to explore them. An idea comes to mind, and it is rejected as inappropriate; or you decide that it is too difficult or that it will not work. First ideas, because they are "obvious," come to mind immediately, often flowing into the sketchbook before you fully comprehend the problem. They frequently are followed by less promising possibilities. It is important to suspend judgment and record these ideas as well.

Research is likely to facilitate your ideation. How have artists in contemporary situations or in the past solved similar problems? In skimming through sources such as recent journals or art history texts, you are likely to find images that relate to problems which you wish to solve. Note how entire compositions or even select aspects of otherwise unrelated paintings, drawings, or advertisements are linked to the problems that you have defined.

Brainstorm on how the visual clues you have discovered in your research may be transformed for your own needs.

Sketching is the primary tool for this brainstorming. Not only does it create a record of your thought process, but also, the physical act of sketching, coupled with the visual involvement in looking at what you draw, acts as a springboard for new ideas. One sketch leads to another. By setting weak or even "bad" ideas down on paper, two things are accomplished. First, these ideas may have elements that can be modified and combined to create more interesting solutions. Second, setting them down on paper can free you to begin to look for new ideas. If you hold back these seemingly weaker ideas, they can block your thinking and obstruct the ideation process. Exhausting obvious possibilities enables you to move on to different areas of specialization. This is not to say that a more obvious first idea will not be the best solution, but rather to suggest that innovative ideas are most often the result of exhaustive thought.

Only after generating as many ideas as possible should you begin to judge them. It can be useful to set specific goals for ideation. For example, you might decide to sketch until you come up with thirty ways to answer the problem. If you judge your ideas as they are generated or proceed beyond ideation without generating a sufficient pool of ideas from which to choose, you can short-circuit your creative process.

Judgment

Having generated a range of possible responses to the problem at hand, you are now ready to judge them, seeking to choose the best. This choice should be based on

the understanding of the problem developed during the problem definition stage. Most serious problems in the creative process arise from bad judgment. This does not necessarily mean that the decisions and choices are in and of themselves bad. Rather, the timing may be off. We may either judge too soon, during the ideation process, or not at all.

At times you may be confronted with critical choices and fail to make any judgment at all, simply accepting what you have done. This passivity may be an attempt to avoid responsibility for certain aspects of your work. The unwillingness to judge can result from a natural reluctance to find your work inadequate or to accept the need to return to an earlier stage of the design process. This is a failure of acceptance, of truly wanting to solve the problem. It is important to realize that starting over may be more expeditious than trying to repair mistakes in achieving successful results.

It is also easy to judge your work too quickly. This may be the result of impatience in trying to reach a solution or failure to take your choices seriously. Decision making is at the very core of the design process. When you stop making choices, you cease to function as an artist or designer and you reduce your own potential. Design takes courage—the courage to confront what you have done and to take the risk of trying things that may not work out. Design involves the courage to recognize elements of your work that are not functioning and forcing yourself to accept the responsibility of restructuring the image until it succeeds.

Image making generally encompasses alternating and overlapping periods of both creativity and labor.

Seldom will an artist or designer be confronted with a good idea, fully realized, requiring only simple labor for its completion. Creative problem solving requires continuing awareness of the effectiveness of your efforts in both of these areas.

Realization

There is more to a successful work of art or design than merely a good idea. If all that was required were good ideas, you could ensure the quality of your work by simply copying the ideas of your more successful colleagues. What differentiates outstanding from mediocre work in any field is not the ideas behind it, but the realization of those ideas. The quality of your work will depend to a large extent on your manual skills, how well you are able to manipulate materials, and your experience; but you should not be dismayed if you are just beginning to make images and have limited skill and experience. Skills are often best acquired "on the job," and each exercise you undertake adds to your experience.

There are many ways that you can ensure that your work will be of the highest quality that you are capable of producing. Perhaps most important is to give yourself enough time. No matter how talented you are, it takes time to finish pieces that convey a sense of authority. Make preparatory drawings (Figure 4). Try out ideas and new media in your sketchbook first or outside the border of your piece. Be prepared to start over from the beginning if you make an error and are unable to make it work to your advantage.

Pause regularly. Step back from your work and ask

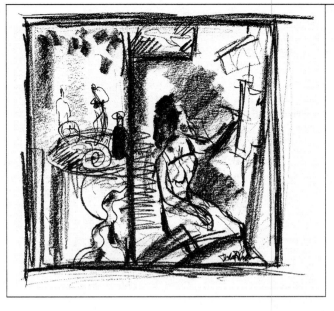

FIGURE 4 Judith Baker, untitled preparatory drawing, 1998, Conté crayon, 14″ × 20″. Courtesy of the artist.

Analysis

This is the final, and perhaps most important, stage of the creative process. When you have finished your work, it is time to step back and analyze what you have done. From this analysis can come an appreciation of the strengths and weaknesses of your current work, and this appreciation will add to your experience and contribute to the foundations upon which your future work will rest. As the chart in Figure 3 indicates, analysis leads directly back into the beginning of the design process. The insights gained from critique and analysis are used to redefine the problem facing the artist, delineating new challenges and enabling a new beginning. The final chapter of this book offers specific strategies for analysis.

COLLEGE AND CAREER

In coming to college to study art you are acknowledging the talents and skills that you already possess and your commitment to improving your abilities. College is a place where people come together to learn. The word comes from the Latin *collegium*, which refers to collegial relationships or to an amiable partnership. A college may be thought of as a group of colleagues gathered together to educate themselves and one another. The sharing and advancement of knowledge is its primary purpose.

yourself if it is accomplishing the goals you have set. Does it communicate as well from a distance as it does up close? Remember, you will have spent hours looking at your image from a distance of only an arm's length. It may be judged by others looking at it from across the room for only a moment. Your work should speak for itself, without your having to explain how it was supposed to look. "What we see is what we get!"

In addition, the work should call attention to the care you devoted to its final appearance. This care you take in your work suggests its importance to you. Present your finished work as professionally as possible.

One of the benefits of coming to a school to study is the opportunity to pursue your development as an artist or designer in the company of a committed group of peers engaged in the same undertaking. Art school is distinguished from apprenticeship, with its emphasis on the one-on-one relationship between master and apprentice, by this gathering of students. Unlike the nineteenth-century academies built around the idea of training students to emulate masters, the vitality of contemporary art departments depends on the free and open exchange of ideas between students and faculty. The quality of your college experience will depend as much on your relationships with your fellow students as it will on your relationships with your professors.

In higher education the primary responsibility for learning is placed on the student. Professors provide their students with opportunities to learn. Their role is to challenge rather than to provide tried and true solutions. They work to create a stimulating environment where learning can flourish, and as practicing artists, they serve as role models. It is your job to absorb as much as you can from your professors and your fellow students. Not unlike books in the library, they exist as resources.

ART AND ATHLETICS: AN ANALOGY

The development of artistic ability may be compared to the development of athletic ability. In art as in sports, achievement is measured in terms of performance rather than training. This is not to deny the importance of training, but rather to recognize that the best coaching cannot make an outstanding athlete if the aspirant's desire and commitment are insufficient. There are champions who overcome difficult physical obstacles and excel, and "natural athletes" who find themselves unable to compete at the college or professional level. Those who succeed are those who practice.

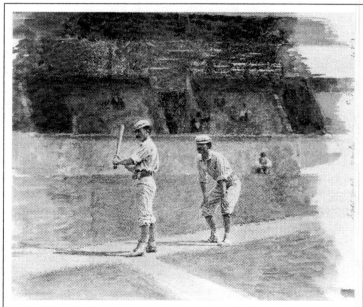

FIGURE 5 Thomas Eakins, *Baseball Players Practicing*, 1875, watercolor, $10^{7}/_{8}$″ × $12^{7}/_{8}$″. Museum of Art, Rhode Island School of Design: Jesse Metcalfe and Walter H. Kimball Funds.

Artistic skill is acquired much like athletic skill. To some it seems to come naturally, but most of us are not so fortunate. Learning to make art can be likened to learning to run hurdles. You are confronted with a very complicated task requiring a developed sense of coordination and timing in a setting where failure will be instantly noted by those around you. Some freeze. If you decide to go ahead and try, you may be overwhelmed in the beginning by all of the things you are trying to remember. When you do combine sprinting and hurdling for the for the first time, it is with great effort and it feels awkward. The process seems jerky rather than smooth, and you seem in constant danger of falling. If you are persistent in your efforts, however, you will one day begin to internalize what you have been practicing. In retrospect, your coordination and sense of balance will seem to have come effortlessly.

Likewise, if you are diligent in your practice as an artist, you will internalize your lessons, and your work, occasionally, will become effortless. Unfortunately, that state of being perfectly in tune usually fades, and you must go back to your exercises, working to regain the ability to perform intuitively. Practice, hard work, and concentration will again reward you.

You might think of school as being like spring training for baseball players. An individual who is a strong fielder but a weak hitter will concentrate on batting practice. In training you work on your areas of weakness. Similarly, you should look at difficult assignments as opportunities to develop new strengths rather than seeing these projects as obstacles to be avoided.

Athletes exercise. They practice. In this, too, the development of artistic skills is similar to the development of athletic skills. Most of the assignments you will be given in your first year of art school are exercises. They are designed to help you develop certain abilities. A good assignment, like a good exercise, can be repeated. Athletes never stop working out, and neither should artists.

If you want to excel, you must consistently put forth your best work. In the future you will be judged by your body of work. This emphasis on your performance, as demonstrated in the objects you produce, can liberate you from focusing solely on getting good grades. Your future opportunities will be based on the impression made by your work. Just as "walk-ons" show up at tryouts without having been recruited and make the team because of their performance, so you can open doors for yourself if your portfolio is strong enough.

PROFESSIONALISM

Though you may be just at the beginning of your formal art studies, you are laying the groundwork for your professional practice as an artist. That being so, it will be important for you to form productive habits regarding your studio work. You will be fostering an attitude of respect for your own efforts that will be conveyed to others.

Some of the first key decisions you make will be with regard to the materials you employ to make your art. In today's economic environment, everyone needs to become sensitive to the expenses associated with art supplies and to learn to make practical and livable choices with regard to materials. Certainly all artists feel frustrated when confronted with having to curtail the amount

of work they are inclined to produce because the cost of supplies is prohibitive.

Often a major expense associated with two-dimensional design is paper. For sketching and day-to-day studio practice, you are likely to find newsprint and other similar papers of relatively low archival value to be your best choice. However, for major projects or assignments that require considerable time and effort, you probably will want to use papers that will guarantee permanence for the finished piece. (See the glossary entry for PERMANENCE.) Keep in mind that the audience for your finished work is likely to associate lower quality materials with a casual attitude on your part. While you may wish that the impact of a work will be informal in nature, you also might want that casualness to be communicated by the image on the paper, rather than by the paper itself.

Another concern that should be addressed early in your career is the storage and documentation of your art. Works that you plan to store for considerable periods of time need protection from the damaging effects of such things as dust, humidity, and light. Works on paper should be stored flat. Individual works may be layered, but they should be separated by clean, acid-free sheets of paper. Boxes made of acid-free cardboard are a less expensive alternative to the metal storage units.

While many artists prefer to use bins to store paintings on canvas, canvases also may be removed from their stretcher bars and rolled. The canvas should be rolled around a rigid tube with the painted side facing away from the tube. Some experts also advise placing glassine paper over the painted side of the canvas.

As your career progresses, you will find that having photographic documentation of your work is a necessity. Slides have become the favored means of documenting images in part because their production cost is relatively inexpensive and because they are conveniently stored in archival boxes or plastic archival sleeves. Slides are still the basis by which many juries make selections for competitive exhibitions, grants, and scholarships.

Because looking at works of art through slide reproductions is nearly ubiquitous today, many artists make the effort to become skilled at using a 35 mm camera in order to document their work. Videotaping images or making still photographs which in turn may be scanned onto a computer disc are other possibilities that are growing in popularity for recording works of art.

Whether you are documenting your images in slides or on videotape, keep in mind that you will want to record the title of each piece (or note if it is untitled), the date of its completion, the materials from which it is made, and its dimensions (height, then width). With slide images, it is customary to place a red dot in the lower left-hand corner of the slide frame. This will indicate to others which side of the slide is to be viewed as up (Figure 6).

Another aspect of your growth as an artist, which you will develop even as you are just beginning to take art classes, is your visual literacy. Your knowledge of the history of art and design will increase rapidly and will be fostered both in classroom situations and by more casual means. Familiarizing yourself with your school library and the vast range of periodicals aimed at artists and designers will undoubtedly be beneficial as you investigate both historical and contemporary sources for ideas

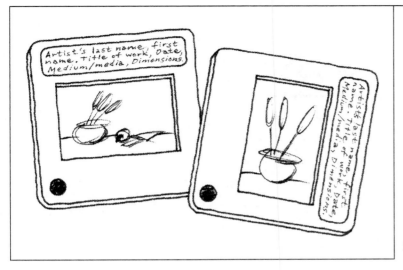

FIGURE 6 Labeled slides.

and inspiration. Trips to galleries and museums are essential, and with so many respected institutions placing images on Internet web sites, your opportunities to familiarize yourself with the collections of even distant museums grow every day.

Finally, it is essential that from the beginning of your training you make safety a significant issue. Be aware of the toxicity present in many commonly used artist's materials and the precautions you should take when you use them. Your instructors and well-staffed art supply stores will be able to provide you with up-to-date information and advice. Make certain that your home work space has adequate ventilation. Taking responsibility for your health and well-being as you manipulate potentially dangerous products and tools is an important first step in establishing your career.

CHAPTER TWO

The Glossary

The bulk of your energies in studio classes will be devoted to making actual images. You will do exercises in response to assignments presented by your instructors, and your efforts will be reviewed in regular critiques. For you to make the most of these classes and to apply the creative problem-solving strategies discussed in Chapter 1, it is essential that you have a broad command of the verbal and visual vocabulary of the arts. This section is designed to provide you with a basic understanding of the terms that you are likely to encounter in assignments and critiques, and to expose you to a sampling of modern and contemporary works of art. Terms appearing in small caps in the definitions are defined elsewhere in the glossary.

We indicated in the first chapter of this book that you need to learn as much as you can from your instructors and fellow students, and while some of this learning can come from attentive observation and listening, much of it will emerge from dialogue. If you are going to communicate effectively with your colleagues, it is essential that you develop a shared vocabulary. This glossary will provide a beginning. We have intentionally limited the glossary definitions to widely used terms and have focused on definitions that reflect current usage.

Just as effective dialogue depends on a shared visual vocabulary, so also is it enriched by a shared visual vocabulary. Often in art, we need to express ideas or concepts that words can describe only approximately. Our ability to communicate these ideas is enhanced if we are able to refer to familiar images. The illustrations in this text provide a basis for developing this shared visual vocabulary.

abstract to generalize, summarize, or distill. Abstraction takes place whenever an image is translated from one method of representation to another.

When writing a paper, you may be asked to first submit an abstract. In this context, an abstract is a brief statement that summarizes the intent of the writer and the content of the paper. An abstract of the title of a piece of property is a concise history of its ownership. Abstraction in these non-art situations requires a manner of approaching information that parallels the concerns of the artist in the studio.

Art and design can be understood in terms of degrees of visual abstraction. The form this abstraction takes varies from individual to individual and is defined by a wide variety of factors, but all art is

united in that it seeks to express some essential information about the world in which it exists.

Two approaches to abstraction can be seen in portraits by Alice Neel (Figure 7) and Willem de Kooning (Figure 8). The Neel is more NATURALISTIC than the de Kooning, yet the modifications of visual reality are numerous. Among these modifications are an emphasis on CONTOUR, which does not occur in reality, and a concentration on detail in the hands and face relative to other parts of the figure. There is a long tradi-

tion in portraiture of selective attention as a means of evoking the personality of the sitter. De Kooning employs a more aggressive abstraction of the figure. While in some sections he makes emphatic use of CONTOUR LINES, in others he allows the figure to blur and merge with the background. Body proportions are distorted, and the placement of specific parts of the body is in response to artistically sensed appropriateness instead of objectively observed reality. This seemingly chaotic representation of the figure enables him to

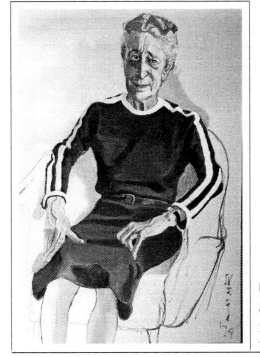

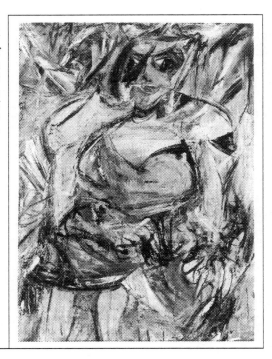

FIGURE 8 Willem de Kooning, *Woman II*, 1952, oil on canvas, 59″ × 43″ (149.9 cm × 109.3 cm). The Museum of Modern Art, New York. Gift of Mrs. John D. Rockefeller 3rd. Photograph © 1999 The Museum of Modern Art, New York, © 2000 Willem de Kooning Revocable Trust / Artists Rights Society (ARS), New York.

FIGURE 7 Alice Neel, *Isabel Bishop*, 1974, oil on canvas, 44″ × 30″. The Montclair Art Museum. Museum purchase; National Endowment for the Arts Museum Purchase Plan. 1977.43.

convey a sense of urgency and vitality that would be impossible with a more naturalistic representation.

abstract art a term used by some to describe NONOBJECTIVE ART and those modernist movements that are devoted to a high degree of abstraction. Among the movements referred to are ABSTRACT EXPRESSIONISM, CUBISM, FUTURISM, and SUPREMATISM.

Abstract Expressionism a MOVEMENT of the late 1940s and 1950s characterized by large, bold, highly ABSTRACT or NONOBJECTIVE canvases; a commitment to the importance of PROCESS; and highly subjective and introspective subject matter. The abstract expressionist movement focused international attention on New York City as a center of painting.

A major catalyst for this movement was the influx of immigrant European artists in the period immediately preceding and during World War II. These artists brought with them radical new ideas and concepts that challenged many of the conservative attitudes dominant in America, including perceptions fostered by REGIONALISM. Foremost among these new ideas was an emphasis on emotional involvement in the process of PAINTING. In addition, the Abstract Expressionists were influenced by the SURREALIST emphasis on myth, the importance of the subconscious mind, and unorthodox working methods including AUTOMATISM. Abstract Expressionism placed a greater emphasis on JUNGIAN theories rather than the older FREUDIAN theories embraced by the Surrealists.

The Abstract Expressionist movement contained two related but discernibly different branches, ACTION PAINTING and COLOR FIELD PAINTING. Major artists associated with Abstract Expressionism include Willem de Kooning (Figure 8), Arshile Gorky, Adolph Gottlieb, Lee Krasner, Barnett Newman, Jackson Pollock (Figure 11), and Mark Rothko (Figure 9).

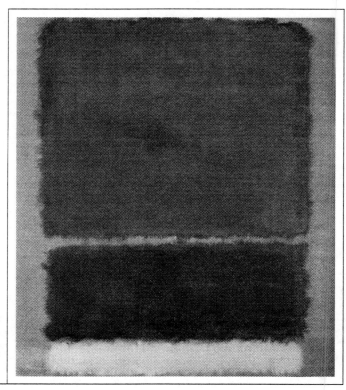

FIGURE 9 Mark Rothko, *Blue, Orange, Red*, 1961, oil on canvas, 7'6¹/₄" × 6'9¹/₄". Hirshhorn Museum and Sculpture Garden, Smithsonian Institution, Gift of the Joseph H. Hirshhorn Foundation, 1966. © 2000 Kate Rothko Prizel & Christopher Rothko / Artists Rights Society (ARS), New York.

academic a manner of working that recalls the training of the nineteenth-century academies such as the French Academy. Academic work is characterized by an objective approach to REPRESENTATIONAL imagery, precise DRAWING, and carefully balanced COMPOSITION.

accent a minor contrasting element that exerts a major influence on the compositional structure of an image. In Edward Hopper's *Early Sunday Morning* (Figure 10), the rounded forms within the fire hydrant and atop the barber's pole serve as accents to the otherwise rectilinear geometric patterns evident within the composition as a whole. In their respective placements, the fire hydrant and the barber's pole also interrupt a regular sequence set by the windows and doors of the string of storefronts.

achromatic literally "without chroma"; devoid of HUE. When the INTENSITY of a COLOR is reduced to zero, when all of its chroma is neutralized, it appears gray. An image or object may be thought of as achromatic if it is composed entirely of black, white, and gray, or of colors whose intensities are so low that hue is visually inaccessible. Black and white photography, drawings in graphite or charcoal, and prints in black or gray inks may be thought of as achromatic.

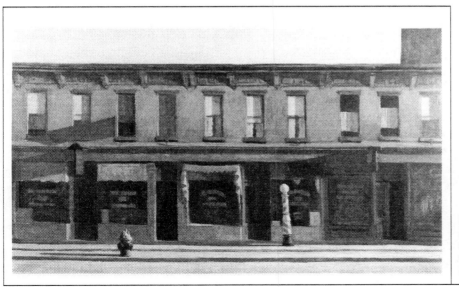

FIGURE 10 Edward Hopper, 1882-1967. *Early Sunday Morning*, 1930, oil on canvas, 35″ × 60″ (88.9 cm × 152.4 cm). Purchase, with funds from Gertrude Vanderbilt Whitney. © 1998. Collection of Whitney Museum of American Art, New York.

acrylic paint that uses acrylic polymer as its BINDER. Acrylic paints may be purchased in tubes or jars, and their consistency may vary from liquid to viscous. Acrylics are quick drying compared to OIL PAINTS, and their PERMANENCE and flexibility allow them to be used in a variety of techniques and combinations. The acrylic POLYMER MEDIUM may be purchased separately and mixed with various materials to build a flexible but solid textural surface.

Action Painting a PAINTING STYLE characterized by dripped, thrown, and spattered paint. "Action" Painting implies the physical action of the artist. This style emerged as an aspect of ABSTRACT EXPRESSIONISM. Because action painting employs the broad muscular gestures of the artist, works tend to be large in FORMAT. The controlled dripping and splattering of the paint places an emphasis on the PROCESS that brings the painting into being (Figure 11).

additive color a color whose HUE is established by the combining of MONOCHROMATIC light sources. Computer monitors and color television employ additive color to create the range of hues, values, and intensities that make up the image. Additive color is also used in theatrical lighting, in which spotlights of the PRIMARY hues may be overlapped to create white. The additive primary colors are red, green, and blue. When mixed additively, they yield colors of higher VALUE and INTENSITY, as illustrated in Figure 12.

aerial perspective see *atmospheric perspective*

aesthetic beautiful; stimulating to the senses in a manner that combines intellectual as well as perceptual involvement.

Aesthetic also refers to standards of beauty, correctness, or propriety held by an individual or a group. Aesthetics is the study of the concept of

FIGURE 11 Jackson Pollock, *Number 25*, 1950, encaustic on canvas, 10¹/₈″ × 39″. Hirshhorn Museum and Sculpture Garden, Smithsonian Institution, Gift of the Joseph H. Hirshhorn Foundation, 1966. © 2000 Pollock-Krasner Foundation / Artists Rights Society (ARS), New York.

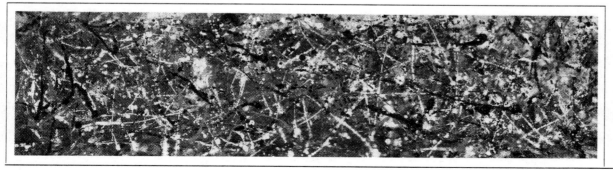

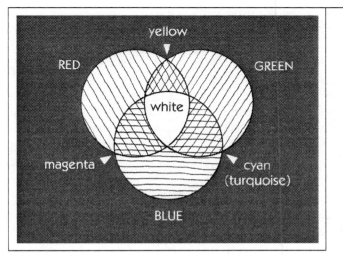

FIGURE 12 Additive color effects.

beauty, how it is defined, and how people experience and understand it.

afterimage the phenomenon of visual perception that persists or emerges after visual stimulation is removed. Strong visual stimuli, such as bright lights or brilliant colors leave a COMPLEMENTARY afterimage. This experience is thought to be the result of fatiguing the sensing nerves of the eye. If you look away to a neutral surface after staring at a brilliant COLOR, you will "see" the complement of that HUE. Similarly, staring at a bright light creates a temporary "black hole" in your field of vision.

FIGURE 13 Roger Brown, *The Decline of the American Empire*, 1985, oil on canvas, two panels 72″ × 48″. The Roger Brown Study Collection of The School of the Art Institute of Chicago and the Brown family.

airbrush a tool used to apply paint or ink in a precisely controlled spray. An airbrush can be used to create uniform modulations in COLOR. It is usually used in combination with FRISKET stencils to create hard edges.

alkyd a painting MEDIUM in which the BINDER is an alkyd resin which combines the quick-drying qualities of ACRYLIC with the compatibility of a variety of solvents that characterizes OIL paints.

allegorical NARRATIVE art in which the story is symbolic. An allegory may be thought of as a drawn-out metaphor. Allegorical images or stories often have a moral or ethical message. Roger Brown's painting *The Decline and Fall of the American Empire* (Figure 13) depicts the financial oppression of the common man

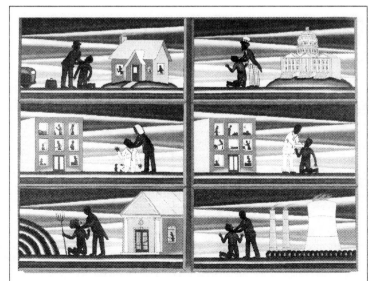

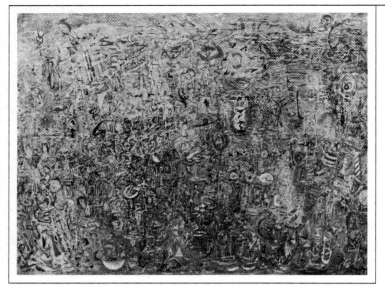

FIGURE 14 Mark Tobey, *Pacific Transition*, 1943, tempera on paper, 23¼″ × 31¼″, Gift of Joseph Pulitzer, Jr. 242:1954, The St. Louis Art Museum (Prints, Drawings and Photographs). (ISN 28654). © 2000 Artists Rights Society (ARS), New York / Pro Litteris, Zurich.

by forces ranging from taxes in the guise of Uncle Sam to medical expenses in the figure of the doctor.

allover an approach toward COMPOSITION in which all parts of the image carry equal visual weight. In Mark Tobey's PAINTING (Figure 14), the subtle differentiations of LINE, COLOR, and SHAPE contribute to the allover compositional effect through their repetition and distribution throughout the CANVAS.

amorphous literally without form. Forms that are loosely, incompletely, or vaguely defined may be described as amorphous (Figure 14).

analogous colors colors whose HUES are adjacent to one another on the circumference of the COLOR WHEEL. Analogous colors are families of colors such as blues, blue-greens, and greens, or yellows, browns, and oranges (Figure 15).

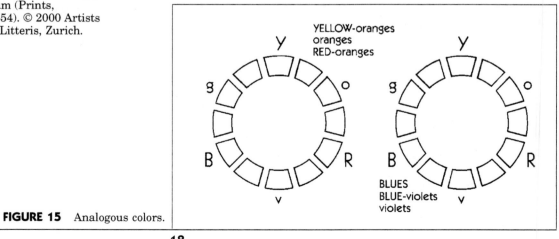

FIGURE 15 Analogous colors.

analogous harmony a COLOR scheme that is dominated by a single group of ANALOGOUS COLORS.

angular perspective see *two-point perspective*

animation a process that creates the illusion of movement through a rapid series of related still images, particularly drawn images. PHOTOMONTAGE and photographic images of three-dimensional models also are used in the process of film animation. COMPUTER-AIDED DESIGN, including programs such as Silicon Graphics Imaging (SGI), has increased animation possibilities.

apparent color see *perceived color*

appropriation the taking for oneself, without permission, of the COMPOSITION, IMAGERY, STYLE, technique, CONTENT, or other aspect of the work of others.

Artists employ a wide-ranging visual environment as a source for imagery and ideas. Appropriation occurs when images made by others, whether from the realm of the fine or the applied arts, are borrowed, making a purposeful reference to a shared vocabulary of visual forms.

The appropriation of any IMAGERY from readily recognizable works draws the source and its par-ticular meanings to the viewer's consciousness, tempering or altering the CONTENT of the new work. Edouard Manet's *Olympia* (Figure 16) outraged the public because it depicted a prostitute in a pose that traditionally suggested noble beauty. The model's reclining pose mimics those employed by the Renaissance painters Giorgione and Titian to express concepts of love and devotion. Manet's concerns are more banal, and the painting draws power from the irony implicit in appropriating the imagery.

Appropriation is a central aspect of the investigations of such POSTMODERNIST artists as Sherrie Levine. Like much CONCEPTUAL ART, Levine's paint-

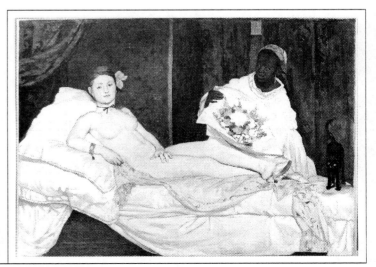

FIGURE 16 Edouard Manet, *Olympia*, 1863, oil on canvas, 51³/₈″ × 74³/₄″. Musée d'Orsay, Paris.

ing (Figure 17) focuses on ideas and issues beyond the object itself. Her copy of an image taken from an old "Krazy Kat" comic directs attention to the issue of "context" and how the sensations provided by her work, which exists in the sphere of the fine arts, differ from those offered by her source, which originated within popular culture. Here, such an impersonal mode of painting, which owes to Levine's direct quotation of the Mr. Austridge cartoon, raises general questions concerning originality, the ownership of ideas, and artists' psychological attachment to their subject matter. See also *derivation*, *Postmodernism*

Armory Show perhaps the single most important exhibition of art in the twentieth century. This show, officially known as the International Exhibition of Modern Art and held in an armory in New York City in 1913, provided a large sector of the American press and public with an abrupt introduction to European modernist art. Although there were a number of sympathetic critics and patrons, the show generated widespread ferment, and a circuslike atmosphere prevailed as nearly 300,000 flocked to see works by IMPRESSIONIST, POST-IMPRESSIONIST, FAUVE, and CUBIST painters. These European (primarily French) works were regarded by many as radical and an assault on the traditions of Western art. Numerous CANVASES were subjected to specific ridicule, including Marcel Duchamp's *Nude Descend-*

FIGURE 17 Sherrie Levine, American, Untitled (Mr. Austridge: 6), 1989, casein on wood, 27¼″ × 47¼″, 69.2 cm × 120 cm. Eliza McMillan Fund, 156:1990. The St. Louis Art Museum (Modern Art).

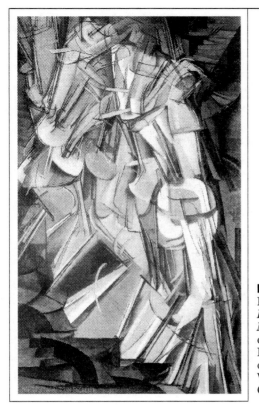

ORGANIC forms and flowing lines. As with Art Nouveau, the use of repeated shapes and pattern also characterize Art Deco design (Figure 19). Taking

FIGURE 19 Jack Rivolta, *Up Where Winter Calls to Play*, Lake Placid Bobsled Poster, 1936-41. Color silkscreen, 21″ × 16½″. Corbis.

FIGURE 18 Marcel Duchamp, *Nude Descending a Staircase No. 2*, 1912, oil on canvas, 58″ × 35″. Philadelphia Museum of Art: Louise and Walter Arensberg Collection.

ing a Staircase No. 2 (Figure 18), which was called "an explosion in a shingle factory."

Art Deco an international MOVEMENT that reached its height during the 1920s and 1930s. Although less ornate than the ART NOUVEAU, the Art Deco movement continued an emphasis on design inspired by

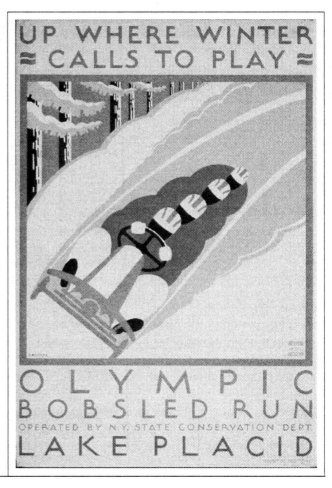

cues from industrial design, many art deco motifs have a streamlined effect.

The term "Art Deco" is derived from the name of the 1925 Paris World's Fair (Exposition Internationale des Arts Decoratifs et Industriels Modernes.) Austin Cooper and Raymond Loewy are among the artists and designers whose works helped to shape the movement.

Art Nouveau French for "new art," a late-nineteenth- and early-twentieth-century MOVEMENT characterized by extreme stylization, DECORATIVE ORGANIC forms, and flowing, curving lines. Art Nouveau was an international movement and is known today through the designs of Henry van de Velde (Figure 20) and the work of such artists and designers as Aubrey Beardsley, Alphonse Mucha, Hector Guimard, and Louis Comfort Tiffany.

artwork a GRAPHIC DESIGN image composed of illustrational material such as a DRAWING or photograph that has been prepared for mechanical reproduction. Though sometimes referred to as a mechanical or a paste-up, these terms may indicate the presence of an image and possibly also TYPE while artwork indicates only IMAGERY. When sent to a printer, finished artwork is accompanied by specific printing instructions. In contemporary practice, much artwork is prepared and submitted for reproduction in DIGITAL media, that is as a computer file or files.

Ashcan School commonly used to refer to a group of early twentieth-century New York City painters whose subject matter focused on humble, everyday urban sights. These painters were indebted to the

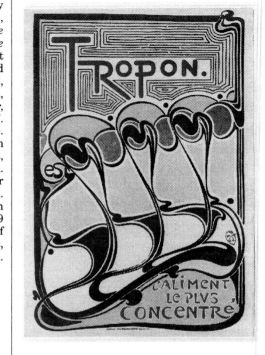

FIGURE 20 Henry van de Velde, *Tropon, L'aliment Le Plus Concentre* [Tropon, The Most Concentrated Nourishment], 1899, lithograph, printed in color, 44″ × 30³/₈″. (111.8 cm × 77.2 cm). The Museum of Modern Art, New York. Arthur Drexler Fund. Photograph © 1999 The Museum of Modern Art, New York.

traditions of nineteenth-century REALISM in both their choice of subject matter and in their use of lively and textural brushwork. They encountered severe criticism from some who felt that their IMAGERY was sordid and tawdry, but the Ashcan School's affront to conservative American tastes was soon eclipsed by the presentation of modern European art in the 1913 ARMORY SHOW.

Among those artists associated with the Ashcan School are George Bellows, Robert Henri, George Luks (Figure 58), and John Sloan.

FIGURE 21 Jean Dubuffet, *Landscape with Three Trees*. 1959. White mullein, vine, wild sorrel, spinach, beet and watercolor on paperboard, 22³/₄″ × 22¹/₄″. Hirshhorn Museum and Sculpture Garden, Smithsonian Institution, Gift of Joseph H. Hirshhorn, 1972. Photographer: Lee Stalsworth.

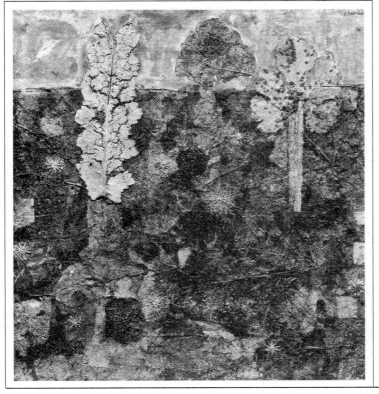

assemblage coined by the artist Jean Dubuffet to describe his COLLAGE compositions (Figure 21). The usage of the term today generally has expanded to include reference to THREE-DIMENSIONAL works composed of a variety of FOUND OBJECTS.

asymmetrical balance balance achieved by contrasting differences in VALUE, size, or significance, independent of SYMMETRY. Degas's painting *Jockeys Before the Race* (Figure 22) is an outstanding example of asymmetrical balance. Degas establishes an

FIGURE 22 Edgar Degas, *Jockeys Before the Race*, ca. 1878-79 (oil, essence, gouache and pastel on paper) 107.3 cm × 73.7 cm. The Barber Institute of Fine Arts, the University of Birmingham/ Bridgeman Art Library, London.

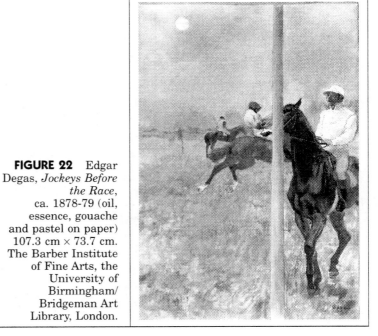

off-center AXIS by placing the pole to the side of the center of the work and by balancing the vital activity of the horses with a much broader expanse of quiet and calm.

atmospheric perspective a means of enhancing the illusion of PICTORIAL SPACE by representing the natural effect of air or atmosphere between the viewer and distant objects or forms. This is achieved by a general graying and reduction in INTENSITY and sharpness of elements within the COMPOSITION as they recede into space. Objects that are close to the viewer are rendered with higher VALUE contrasts, crisper detail, and higher-INTENSITY colors than objects at a distance. In addition, atmospheric intervention shifts HUE toward the blue or COOL side of the COLOR WHEEL.

Atmospheric perspective can be seen in Berthe Morisot's *View of Paris from the Trocadero* (Figure 23). In this freely brushed PAINTING, the gradation of space from near to middle to far is achieved by diminishing the sharpness and detail between the foreground and middleground and representing the distant cityscape as softly defined forms bathed in an all-encompassing, purple-gray haze.

automatism a passive process of creation in which the artist essentially allows the work to create itself,

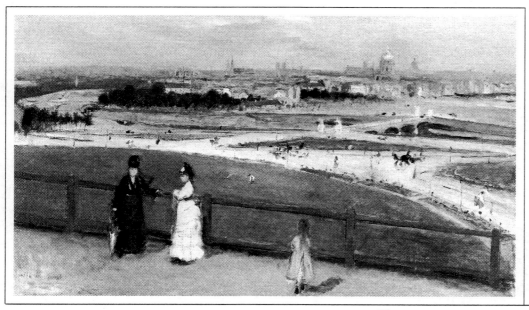

FIGURE 23 Morisot, Berthe Marie Paul, *View of Paris from the Trocadero*, 1871-72, oil on canvas. 18$^{1}/_{16}$" × 32$^{1}/_{16}$". Santa Barbara Museum of Art, Gift of Mrs. Hugh N. Kirkland.

avoiding the influence of any preconceived notions of the finished piece. Chance effects, such as those employed by Jean Arp (Figure 48) and others of the DADA movement, are used as a means of separating the artist's conscious control from the work at hand.

One realization of automatism is in the form of automatic drawing, where the same sensibility is applied to the making of drawings. Doodling, drawing created without conscious direction, may be thought of as a trivial form of automatic drawing. The SURREALISTS, including Max Ernst and Joan Miro, sought to release potent images and forms embedded in the conscious mind through automatic drawing, using the process as a visual equivalent of Freud's verbal free association. See *Freudian*

avant-garde a French military term used to describe a small group of soldiers sent in advance of the larger body of troops. In art, the term avant-garde is that small group of artists that, seemingly without fear, takes artistic risks and challenges the boundaries of what is acceptable.

The avant-garde is associated with the very beginnings of MODERN ART. The REALIST painters Gustave Courbet and Edouard Manet (Figure 16) were among the avant-garde of their time. Their work challenged the status quo and faced the ridicule of the art public. Their images and ideas later gained acceptance among their fellow artists and were absorbed into the larger IMPRESSIONIST movement, which continued and extended their challenges.

This same pattern has been repeated throughout the twentieth century and can be seen in the history of such avant-garde movements as CUBISM and SURREALISM. The current abundance of directions and concerns in CONTEMPORARY ART, coupled with their wide acceptance, challenges the possibility of an avant-garde today. In an age when all possibilities are open, it may be impossible to find conventions to challenge or barriers to break down. See also *Postmodernism*

axis the perceived center or spine of a shape; the "dividing line" in a symmetrical image. An axis is a line around which an image or part of an image is organized.

balance the sensed structural stability resulting from looking at images in terms of gravity and physical mass and judging them against "commonsense" ideas of physical structure. Balance generally refers to the relationship between the left and right sides of an image rather than between top and bottom. It is usually the result of weighing dissimilar elements and is responsive to HUE, VALUE, INTENSITY, and shape as well as placement.

Balance is a quality that all images have to a greater or lesser degree. The extent to which balance results from the interaction of dissimilar elements has a direct bearing on the visual excitement of the piece. Artists employ a wide range of devices and methods to achieve a desired state of balance in their works.

Barbara Rossi's *Icelandic* (Figure 24) achieves a strong sense of balance through the repetition of virtually identical shapes on each side of its vertical axis. See also *asymmetrical balance*; *informal balance*; and *symmetry*

Bauhaus a highly influential school of art and design that was established in Germany in 1919 and continued until 1933, when it was closed by the Nazis. The school was devoted to the concept of unity and equality between artists and craftsmen and identified itself with the industrial age. It was the first school to treat the design of manufactured objects as an art. At the Bauhaus, painters and sculptors worked and studied alongside weavers and woodworkers. The Bauhaus broke with the traditional training methods used in the nineteenth-century academies. It originated the idea of a curriculum built on a shared foundation of design training for all students. Although the school encouraged stylistic independence, a Bauhaus AESTHETIC of purified form, precise geometry, and limited color is discernable in many of the objects produced at the school.

Despite its relatively short existence, the Bauhaus attracted an esteemed faculty including Josef Albers, Walter Gropius, Wasily Kandinsky, Paul Klee, Lazlo Moholy-Nagy, Ludwig Mies van der Rohe (Figure 122), and Oskar Schlemmer.

bezold effect describes the optical mixing that creates a PERCEIVED COLOR when small areas of different colors are placed adjacent to one another. The bezold effect is one of the primary devices employed in POINTILLISM. The optical mixing yields results similar to both ADDITIVE-COLOR mixing and SUBTRACTIVE-COLOR mixing. The bezold effect creates colors with more vibrancy and INTENSITY than subtractive mixing but does not produce the higher VALUE of additive mixing. For example, when PRIMARY blue and yellow are mixed subtractively (mixing yellow and blue paint), they yield a middle value, moderate-intensity green; mixed additively (mixing yellow and blue light), they yield a high value, moderate-intensity green; mixed by the bezold effect, they yield a moderate value, high-intensity green.

FIGURE 24 Barbara Rossi, *Icelandic*, 1981, acrylic on Masonite, 28″ × 35″. Courtesy of the Phyllis Kind Gallery—New York. Photo by William H. Bengston.

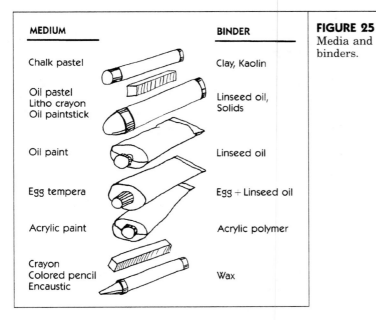

MEDIUM	BINDER
Chalk pastel	Clay, Kaolin
Oil pastel	
Litho crayon	
Oil paintstick	Linseed oil,
Solids	
Oil paint	Linseed oil
Egg tempera	Egg + Linseed oil
Acrylic paint	Acrylic polymer
Crayon	
Colored pencil
Encaustic | Wax |

FIGURE 25 Media and binders.

and reflectivity of light. MEDIA are often defined in terms of their binders (Figure 25).

biomorphic an adjective used to describe configurations that suggest the appearance of plant or animal life, especially lower forms of life such as amoebae and other single-cell organisms.

The soft, curvilinear forms that float throughout Grace Hartigan's PAINTING (Figure 26) are

FIGURE 26 Grace Hartigan, *Inclement Weather*, 1970, acrylic on fabric, 78¼″ × 88¼″, National Museum of American Art, Washington, D.C., U.S.A.

bilateral symmetry the equal placement of visual elements on either side of a central AXIS. This can create a very stable sense of BALANCE.

binder the material or MEDIUM used in paint or a drawing tool to hold the pigments in suspension allowing for their controlled distribution and adhesion to the GROUND. The effect of the binder on a medium is twofold. The nature of the binder determines the working characteristics and feel of a particular medium. In addition, the binder surrounds the particles of PIGMENT, controlling their exposure to the atmosphere and susceptibility to oxidation, affecting the drying properties and the transmission

biomorphic shapes that evoke a range of associations from plant forms to human anatomy.

bird's-eye view a point-of-view in an image in which the scene depicted is shown from an elevated vantage point. A bird's-eye view can convey the feeling that the viewer is included in the image as an unobserved witness (Figure 27).

Blaue Reiter German for "blue rider." An artists' group founded and dominated by Franz Marc (Figure 28), for whom blue was a favorite COLOR,

FIGURE 27 Grant Wood, *The Midnight Ride of Paul Revere*, 1931, oil on Masonite, 30″ × 40″. The Metropolitan Museum of Art, Arthur H. Hearn Fund. 1950 (50.117). All rights reserved. © Estate of Grant Wood / Licensed by VAGA, New York, N.Y.

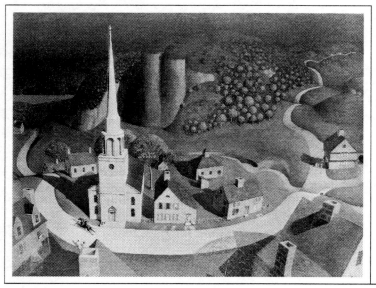

and Wasily Kandinsky, who employed the horse and rider as a repeated MOTIF. The Blaue Reiter was an association primarily of German EXPRESSIONIST artists founded in 1908 and active until 1910. The major focus of the group was the sponsorship of exhibitions of their own work and that of others they felt conveyed a direct, honest, and spontaneous creativity. The Blaue Reiter exhibitions were among the first to display the art of children and NAIVE painters as fine art rather than simply as curiosities.

A major difference between the Blaue Reiter and DIE BRÜCKE is the emphasis placed by the Blaue Reiter on more highly ABSTRACT and NONOBJECTIVE art. The Blaue Reiter artists also stressed a more spiritual, even mystical basis for their art.

In addition to Marc and Kandinsky, the Blaue Reiter included Alexej Jawlensky and Gabriele Münter. Paul Klee also was associated with the group.

bleed the area of a printed image that pushes beyond a normal illustration format to the edge of a page.

body of work a group of works created by a single artist or a group of artists working in COLLABORATION over a specific period of time. In addition to being defined by time, a body of work may be united by issues of FORM or CONTENT as well. An artist's intent is best understood through the consideration of a body of his or her work. This is especially true of contemporary artists whose work may be self-referential and may focus on very narrow areas of conceptual or visual concerns.

body type see *composition size*

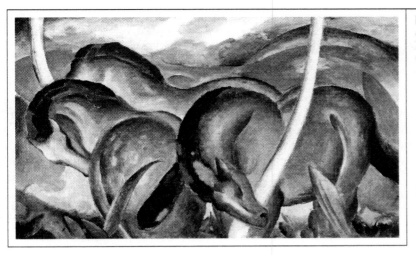

FIGURE 28 Franz Marc, *The Large Blue Horses*, 1911, oil on canvas, 41⅝″ × 71½″. Collection, Walker Art Center, Minneapolis. Gift of the T. B. Walker Foundation, Gilbert M. Walker Fund, 1942.

FIGURE 29 David Tell, untitled, 1979, lithograph, 12″ × 14″. Private Collection. Printed by Normal Editions Workshop, Illinois State University.

bold face a heavier, more visually weighted version of a standard TYPEFACE.

border the edge surrounding the FORMAT of an image. A border can serve to separate an image from the world around it, defining its universe, reinforcing its shape, and providing context for its COLOR, TEXTURE, and IMAGERY.

The border of an image may become a DECORA-TIVE field in and of itself and be embellished by the artist as an integral part of the finished work, as in Figure 29.

Additionally, a border acting as the edge of the format generally functions as either a "window" into the PICTORIAL SPACE of the image, or a frame surrounding the image. When the image employs relatively tight CROPPING, as with the photograph of four

figures sitting on a riverbank, (Figure 30), we relate to the border as a window.

When the image within the picture essentially stands apart from the border, basically centered in its presentation within it, as in the portrait by Alice Neel (Figure 7), we relate to it as a frame.

bristol board a widely used drawing SUPPORT made by pressing several layers or piles of paper together. Bristol board is composed entirely of one material of uniform quality. It is much favored for fine rendering and pen-and-ink DRAWING. It is generally available in COLD PRESS, a slightly textured surface

also referred to as vellum, and HOT PRESS, a smooth surface also referred to as plate or plate finish.

(die) Brücke German for "the bridge." Die Brücke was an artistic community organized in Dresden, Germany, in 1905. The four founders were young architecture students who turned to painting, sculpture, and WOODCUT as more potent vehicles for their personal expressions. They announced their intentions to forge a new link to the creative future through a revolutionary art of intense feeling. The agitated and intensely colored surfaces of Die Brücke canvases challenged the established ACADEMIC traditions,

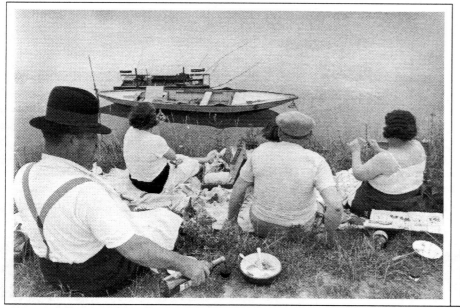

FIGURE 30 Henry Cartier-Bresson, French, b. 1908, *Sunday on the Banks of the Marne*, 1938, silver print, 1954.185. Photograph © 1999. The Art Institute of Chicago, All Rights Reserved.

FIGURE 31 Ernst Ludwig Kirchner, *Street*, Dresden, (1908; dated on painting 1907), oil on canvas, 59¼″ × 6′6⅞″ (150.5 cm × 200.4 cm). The Museum of Modern Art, New York. Photograph © 1999 The Museum of Modern Art, New York.

which dominated German art of the time. Die Brücke artists' bold distortions of form and liberation of color beyond its descriptive function for expressive means were first influenced by Edvard Munch and the POST-IMPRESSIONIST canvases of Paul Gauguin and Vincent van Gogh. Later the FAUVE movement, CUBISM, and FUTURISM made an impact on their paintings. PRIMITIVE ART, particularly African sculpture, also held great significance for Die Brücke artists.

Among the founders of Die Brücke were Erich Heckel and Ernst Ludwig Kirchner (Figure 31). Artists later associated with the group included Otto Mueller, Emil Nolde, and Max Pechstein. (See also *Expressionism, German*).

calligraphy elegant handwriting. Calligraphy is characterized by an expressive line having the qualities of beautiful handwriting. Characteristics such as flow, grace, rhythm, repetition of shapes, and variations in weight may contribute to calligraphic form.

Ray George contrasts GEOMETRIC lines with softer, calligraphic lines (Figure 32).

camera ready describes ARTWORK and any accompanying TEXT, typically adhered to a stiff sheet of PAPER or board, which is ready to be photographed by a process camera in preparation for reproduction.

canvas a relatively heavy fabric made of tightly woven cotton or flax used as a SUPPORT for painting. When flax is used, the canvas is referred to as linen. Canvas may also refer to any fabric used as a support for painting or to a painting on a fabric support.

FIGURE 32 Ray George, *Utica #2*, 1983, charcoal, graphite, and acrylic on paper, 45″ × 56″. Courtesy of the artist.

cartoon a preliminary SKETCH at full size prepared by an artist to aid in visualization and guide in the creation of a complex work such as a FRESCO or tapestry.

casein a paint in which the BINDER is a protein derived from milk mixed with water and ammonium carbonate. True casein is rarely found anymore due to its short shelf life, and it has largely been replaced by ACRYLIC polymer paints.

chalk a drawing material made from soft limestone pressed into sticks. The limestone may be dyed or mixed with pigments to create colored chalks.

charcoal a black, porous, carbon drawing material made from finely charred wood. Charcoal is available in a variety of forms. Vine charcoal is made by charring fine sticks, usually willow, in a kiln. Compressed charcoal is made by combining charcoal powder and a BINDER and pressing them into sticks. It is available in a variety of hardnesses. Compressed charcoal is also available in pencils.

chiaroscuro Italian for "light-dark." Chiaroscuro describes the use of contrasting areas of high and low values to create dramatic effects. Chiaroscuro is used to great effect in Alfred Leslie's painting (Figure 33), a work in GRISAILLE.

chroma see *intensity*

classical having the qualities generally associated with the art of ancient Greece and Rome at the height of their civilizations. The artists of antiquity sought to make ideal images by abstracting the essential qualities of nature and humanity. The works of antiq-uity convey a nobility and elegance that is conveyed by a refined sense of balance and proportion. Picasso's classicizing portrait of a young woman (Figure 34) combines a fresh, candid vision with an abstraction and generalization of forms, creating an idealized and harmonious whole.

FIGURE 33 Alfred Leslie, *Lisa Bigelow*, 1964-66, synthetic polymer on canvas, 259.1 cm × 182.8 cm, Indiana University Art Museum: Purchased with the aid of funds from the National Endowment for the Arts. Photograph by Michael Cavanaugh and Kevin Montague. © 1999 Indiana University Art Museum. Used by permission of Alfred Leslie and the Boil and Squeal Gallery.

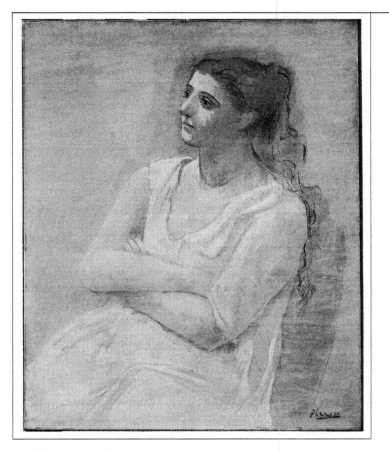

FIGURE 34 Pablo Picasso, *A Woman in White*, 1923, oil on canvas, 39″ × 31½″. The Metropolitan Museum of Art, Rogers Fund, 1951. Acquired from the Museum of Modern Art, Lillie P. Bliss Collection (53.140.4). All rights reserved, The Metropolitan Museum of Art. © 2000 Estate of Pablo Picasso / Artists Rights Society (ARS), New York.

clip art ready made illustrations and designs. Clip art provides a relatively inexpensive and easy means of adding imagery to the LAYOUT of a page. Clip art may be photocopied, then cut or "clipped out," to be pasted on a page. With the use of a computer, clip art is added to an electronic layout as a digital file or by scanning.

cold press a method of making paper or board by subjecting it to pressure without heat, yielding a moderately textured surface. Cold-pressed papers are more absorbent and have more tooth, or texture, than HOT-PRESSED papers.

collaboration the process or product of a group of individuals working toward a single goal.

Designers and artists are usually thought of as working alone. Creativity is associated with uniqueness and individuality. In fact, however, designers often work in teams and almost always collaborate with a client. Working in collaboration can stimulate a cross-fertilization of ideas, capitalizing on the uniqueness of each individual's vision and skills.

Until the twentieth century, fine art, even when made through collective efforts, was almost always attributed to a single individual. During and immediately following World War I, some of the artists of DADA and SURREALISM began to make works together in addition to sharing ideas. Their collaboration was in part an effort to move the focus of art away from the personality of the individual artist and toward the object and its evocative qualities.

A tradition of collaboration has extended into contemporary times, and there are a number of artists

who work together as collaborative teams. Often these teams, such as Group Material, were formed primarily to promote common social and political aims. Artists working in partnership, such as Gilbert and George, Komar and Melamid, and Mike and Doug Starn (Figure 35), link identities through shared formal and conceptual concerns.

In addition to these partnerships, the twentieth century is replete with examples of visual artists collaborating with individuals working in other media. For example, printmakers have collaborated with poets in designing books and painters have worked with producers in the design of theatrical productions.

FIGURE 35 Mike and Doug Starn, American, b. 1961, *Green Mater Dolorosa*, 12 toned silver gelatin prints mounted on board, 1987, 239 cm × 188 cm. The Art Institute of Chicago. Gift of the Cooper Fund, Inc., 1988.164. Photograph © 1999, The Art Institute of Chicago, All Rights Reserved.

collage from the French *coller*, meaning to paste, glue, or adhere. A collage is an image made in whole or in part by adhering a variety of two-dimensional materials to a SUPPORT. The practice was adopted in the fine arts by the CUBISTS.

The materials used in a collage may be printed materials drawn from the external world which maintain their legibility, such as receipts or fragments of magazine pages; they may be unique images, such as pieces of drawings or paintings; or they may simply be pieces of colored or textured material chosen for their decorative potential. The introduction of real materials into a context that we generally associate with illusionistic representation suggests multiple levels of reality (Figure 21). Artists who employ collage frequently tend to bring together materials from widely varying contexts in order to create new pictorial realities.

Collage makes its impact through the juxtaposition of images from varying contexts and our recognition of their original sources.

collagraphy a RELIEF printmaking method in which a COLLAGE is used as the printing plate. The collage is generally built up out of richly textured materials such as cardboard, sandpaper, wallpaper, or fabric. The collage may be sealed with several coats of POLYMER MEDIUM to protect it from damage by ink and solvents.

color the response of the eye to electromagnetic radiation in the visual range (wavelengths from approximately 4,000 angstroms for violet light to 7,200 angstroms for red light). Just as there is

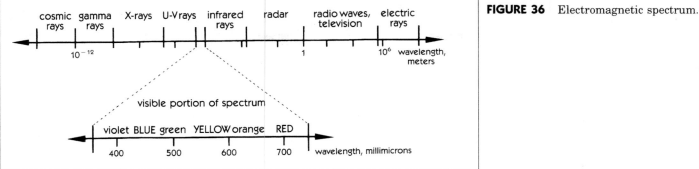

FIGURE 36 Electromagnetic spectrum.

sound outside our audible range, so there is light outside our visual range. Just below the violet range is ultraviolet, then X-rays, and finally gamma rays; beyond the visible red are infrared, microwaves, and finally radio waves. A color has three dimensions: HUE, VALUE, and INTENSITY. Color names describe a specific blend of these dimensions (Figure 36).

Color Field painting a painting style that emerged from ABSTRACT EXPRESSIONISM. It is characterized by large canvases with broad expanses of color in continuous, uniform surfaces, or "fields" with subtle modulation. The fields of color may be punctuated by occasional stripes of contrasting color crossing the canvas; they may flow and expand into broadly defined areas or may be limited only by the edge of the canvas. In Color Field painting, the large scale of the canvas and the sweeping color surfaces engulf the viewer with a sensation of homogeneous color and can inspire a sense of awe and spiritual transcendence. Major Color Field painters include Helen Frankenthaler, Barnett Newman, and Mark Rothko (Figure 9).

color matching systems one of a number of means by which graphic designers and printers can communicate precisely about ink colors in a printed design.

Color matching systems rely on swatchbooks containing a rainbow of hundreds of printed samples. Each color has a numbered code and a formula showing the ink mixture that will create that color. The use of the code allows the designer to designate a highly specific color choice for printing purposes.

Two common color matching systems are Pantone® and Trumatch®.

color temperature a scientific description of the color of radiant light. All matter radiates light when heated to a high enough temperature. This is what we see when steel is "red-hot." In art and design,

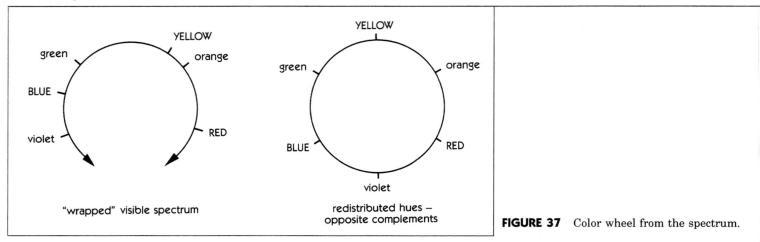

"wrapped" visible spectrum

redistributed hues –
opposite complements

FIGURE 37 Color wheel from the spectrum.

color temperature is used more generally to refer to
WARM and COOL colors.

color wheel a chart showing the interrelationships of
COLORS. It is formed by wrapping the visual spec-
trum into a circle and distributing the HUES so that
COMPLEMENTS will be opposite one another on the
wheel (Figure 37). The color wheel is a useful tool
for exploring the relationships between colors and
the results of mixing colors.

In addition to charting the HUES by their place-
ment around the circumference of the color wheel,
intensities are located along the radii or spokes of
the wheel, with the lowest intensity of each hue
placed at the center of the wheel.

The color wheel functions as a graph of two dimen-
sions of color: hue and INTENSITY. The result of
mixing two colors of paint can be anticipated by

FIGURE 38
Color wheel
as mixing chart.

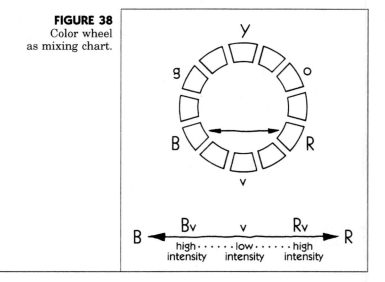

drawing a line between the two colors on the color wheel. The points along the line will match the range of hues and intensities that would result from mixing the two colors in varying proportions. (Figure 38).

There have been many variations on the color wheel since Isaac Newton first suggested that the visual spectrum could be effectively presented in a circle, but the one currently referred to most often is a twelve-hue wheel (Figure 39).

complement literally "to complete." The complement of red is green (yellow + blue). Any color with its complement provides all of the primary hues; therefore, they are complements—they complete one another (Figure 40).

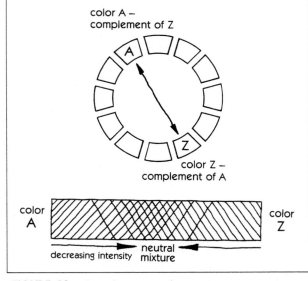

FIGURE 40 Complementary harmony.

FIGURE 39 Color wheel variations.

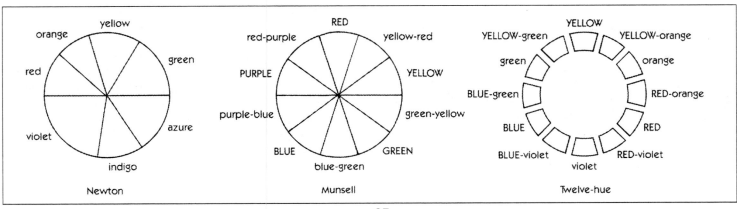

The complement of a HUE is that hue which lies directly across from it on the COLOR WHEEL. When a hue is mixed with its complement in equal strength, the result is a NEUTRAL COLOR. When a small amount of its complement is added to a color, its INTENSITY will be reduced without any shift in its hue. A color wheel is arranged so that a complementary relationship exists between any two hues that lie directly opposite one another on the color wheel.

complementary harmony a color HARMONY built around the relationship of a pair of complementary HUES.

composition the formal arrangement of the visual elements within an image. Composition is distinct from CONTENT.

compositional device a visual technique used to accomplish a FORMAL goal or the contrived placement of an object to create a formal effect or to affect the visual flow of an image.

In Amedeo de Souza-Cardoso's *The Leap of the Rabbit*, a variety of angular, saw-toothed forms are employed as compositional devices which create a sense of pictorial UNITY throughout the CANVAS (Figure 41).

composition size any of a range of TYPEFACE sizes (usually six to fourteen POINT) used for the printing of continuous TEXT, as in the main body of a book or magazine article. Composition size is also referred to as Body Type.

Computer-aided drafting/design (CAD) the use of a computer and specialized software to assist in the

FIGURE 41 Amedeo de Souza-Cardoso, Portuguese, 1887-1918, *The Leap of the Rabbit*, oil on canvas, 1911, 49.8 cm × 61.3 cm. The Art Institute of Chicago. Arthur Jerome Eddy Memorial Collection, 1931.514, Photograph © 1999, The Art Institute of Chicago, All Rights Reserved.

design process, particularly in creating technical drawings. Depending on the software and its applications, images on the computer display screen may be manipulated by moving a mouse or other pointing device through changes indicated on the keyboard. As computer-aided design may be used for both two-dimensional and three-dimensional representations, it has been of special interest to architects and industrial designers.

computer graphics pictures or designs produced with the assistance of a computer.

Conceptual Art a contemporary art movement based on the principle that the true substance of art is ideas and concepts rather than images or artifacts. Throughout the twentieth century, there has been a continuing insistence by some that art is not primarily a product of craft or technique, but rather of the creative powers of the intellect. The first movement to focus specifically on ideas rather than artisanship was DADA

Many conceptual artists are opposed to creating permanent, precious artifacts. They often provide DOCUMENTATION as the only lasting physical product of their work.

Joseph Kosuth presents three representations of the concept "chair" in his piece that brings together a photograph, a three-dimensional object, and a dictionary definition (Figure 42).

Constructivism a Russian art movement of the late 1910s and early 1920s concerned with the union of art, engineering, and technology. The founder of

Constructivism, Vladimir Tatlin, was influenced by CUBISM and FUTURISM, and particularly by Cubist COLLAGE. He began to explore the use of new and

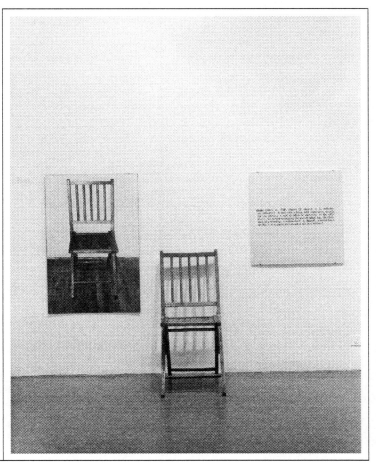

FIGURE 42 Joseph Kosuth, *One and Three Chairs*, 1965, wooden folding chair, photographic copy of a chair, and photographic enlargement of a dictionary definition of a chair; chair, $32^{3}/_{8}'' \times 14^{7}/_{8}'' \times 20^{7}/_{8}''$ (82 cm × 38.7 cm × 53 cm); photo panel, $36'' \times 24^{1}/_{8}''$ (91.5 cm × 61.1 cm): text panel, $24'' \times 24^{1}/_{8}''$ (61 cm × 61.3 cm). The Museum of Modern Art, New York. © 2000 Joseph Kosuth/Artists Rights Society (ARS), New York.

unorthodox building materials, at first combined in NONOBJECTIVE sculptural reliefs, and later in architectural projects. The movement encountered government resistance in the early 1920s but continued to exert an influence outside the Soviet Union. Many artists of the BAUHAUS subscribed to the Constructivist belief in the social responsibility of the artist.

Conté crayon a drawing MEDIUM in stick form, which uses a gum BINDER. Conté crayons are made in France by Conté à Paris and are available in white, sepia, sanguine, and black. They are widely used as an alternative to charcoal for broad gestural drawing and sketching.

contemporary art the art of our own time. Frequently the term is used to describe art since 1945.

content the subject matter, meaning, and cultural context of a work of art. A thorough study of the content of an object extends beyond its appearance to a consideration of the artist's entire BODY OF WORK and his or her place in time and culture.

contour the edge of a SHAPE or FORM.

contour line a LINE that describes or follows the edge of a shape or form—an outline. Alternatively, a line that follows and reveals form, as the lines in a contour map.

cool color a COLOR whose HUE is in the lower end of the spectrum: blue-violet, blue, or blue-green (Figure 43). Cool colors tend to be perceived as receding spatially.

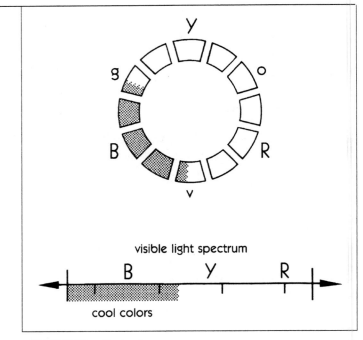

visible light spectrum

cool colors

FIGURE 43 Cool colors.

critique an analysis of strengths and weaknesses, with an emphasis on recognizing strategies for overcoming weaknesses and achieving goals.

cropping the abrupt termination of forms or objects by the edge of the FORMAT or another object. Cropping reinforces the idea of format as a windowlike construction through which the image is seen and the concept of the image as part of a wider world that continues beyond the confines of the picture. Bar-

FIGURE 44 Barbara Kruger, *We Will No Longer Be Seen and Not Heard*, 1985, Photo-Offset Lithograph and serigraph on paper, 9 pieces, each 20½″ × 20½″ (52 cm × 52 cm). Museum purchase. National Museum of American Art, Washington, D.C., U.S.A.

bara Kruger employs an aggressive approach to cropping images, particularly the human figure, in order to enhance the argumentative nature of her work (Figure 44).

Cropping additionally can create interesting NEGATIVE SHAPES, thereby helping to activate the background areas of a picture.

Cropping becomes an effective artistic strategy because of our innate desire to see things as simply and completely as possible.

cropping frame a pair of L-shaped planes that can be moved about over a preliminary SKETCH or other image in order to explore various possibilities of COMPOSITION or FORMAT. An empty frame (sometimes

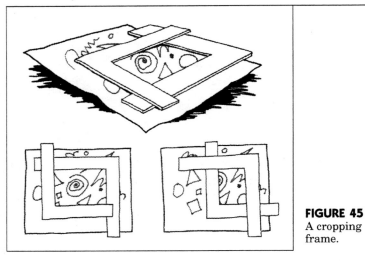

FIGURE 45
A cropping frame.

called a viewfinder) such as a slide mount also can be used as a cropping frame to explore variations in composition within a fixed format (Figure 45).

croquis a quick SKETCH or GESTURE DRAWING, often at a small scale.

cross-hatching a MODELING technique characterized by the use of straight parallel LINES that cross over one another. Variations in the density of the hatching lines can create differences in VALUE, while their direction can be used to enhance the illusion of volume (Figure 46).

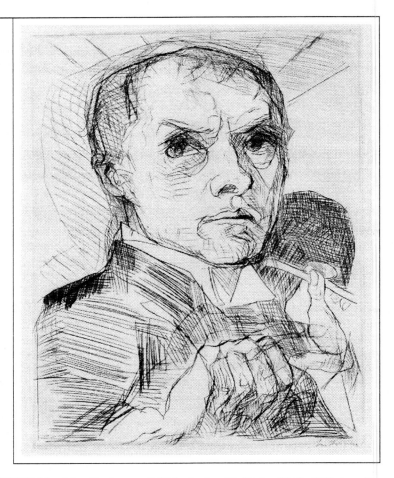

FIGURE 46 Max Beckman, *Self-Portrait with Stylus* (Selbstbildnis mit griffe) from the portfolio *Faces (Gesichter)*. (1916?, published 1919). Drypoint and etching printed in black, plate: 11³/₄″ × 9³/₈″ (29.8 cm × 23.8 cm). The Museum of Modern Art, New York. Gift of Edgar J. Kaufmann, Jr. Photograph © 1999 The Museum of Modern Art, New York.

Cubism an early-twentieth-century art movement initiated by Georges Braque and Pablo Picasso. Cubism offered a complete break with the Renaissance conception of PICTORIAL SPACE as a unified whole, subject to consistent mathematical laws of perspective. The Renaissance notion of the PICTURE PLANE as a "window into the world," in which objects recede into space and diminish in size according to the rules of ATMOSPHERIC and LINEAR PERSPECTIVE, is challenged by the shallow space of Cubism. Cubist images present simultaneous images of objects from multiple points of view, fragmented and faceted forms, and a confusion of POSITIVE and NEGATIVE SHAPE relationships (Figure 47). Cubism offers an intellectual ordering, rather than a purely optical rendering, of the interrelationships of forms in a COMPOSITION. Cubist COLLAGE was an invention responsive to this new approach to form and the structure of composition.

Cubist painters were influenced by the shifting perspectives of Paul Cezanne's paintings and the DISTORTION of the human figure in African sculpture.

In addition to Braque and Picasso, artists associated with the movement include Marcel Duchamp early in his career (Figure 18), Albert Gleizes, Juan Gris, and Fernand Leger. Cubism held tremendous implications for the development of ABSTRACT painting and sculpture.

Dada an international art movement that placed its emphasis on the idea of art rather than art objects. Dada was launched in Switzerland by writers and visual artists as a protest against World War I and the materialistic culture that they felt caused the

FIGURE 47 Pable Picasso, *Female Nude*, 1909-1910, oil on canvas, 28³/₄″ × 21¹/₄″. The Menil Collection, Houston.

strife. The name for the group, French for "hobby-horse," was reportedly chosen at random from a dictionary, reflecting the playfulness and spontaneity that characterized the group's challenge to the seriousness of making art. The members of the group called themselves "Dadas." They sought to make it clear that their movement was not another "-ism," but a total way of living. In their revolt, the Dadas opened a new awareness of creative investigation and forced a reevaluation of the definitions and boundaries of art.

Jean Arp was one of the first Dadas. His experiments involving AUTOMATISM, and specifically those involving COLLAGES made by dropping papers to form random arrangements (Figure 48), are indicative of Dada's challenge to the notion of the artist as a gifted individual, uniquely able to craft an object of artistic merit. His concerns placed new emphasis on the PROCESS of making art as opposed to the finished object.

In his paintings and "readymades," objects taken from a non-art context and exhibited as fine art, Marcel Duchamp, the most significant figure to emerge from the Dada movement, challenged the hierarchy separating "art" experiences from "life" experiences. He forced a new intellectual involvement on the part of the viewer, a questioning of aesthetic values, tastes, propriety.

Dada poses questions of extreme pertinence to contemporary artists. The POP ART emphasis on the merger of art and life, and the concerns for ideas rather than objects that distinguish CONCEPTUAL ART are indicative of Dada's influence.

FIGURE 48 Hans (Jean) Arp, *Collage Arranged According to the Laws of Chance*, 1916-1917, torn and pasted papers, 19 1/8″ × 13 5/8″ (48.6 cm × 34.6 cm). The Museum of Modern Art, New York. Purchase. Photograph © 1999, The Museum of Modern Art, New York. © 2000 Artists Rights Society (ARS), New York / VG Bild-Kunst, Bonn.

Other artists associated with Dada include Max Ernst, Francis Picabia, and Man Ray.

decoration surface embellishment, often in the form of PATTERN.

decorative having as its primary purpose to decorate, embellish, or adorn. The term may be used in a pejorative sense to describe images that rely exclusively on simple visual effects, with little or no attempt to convey substantive meaning or message. Works such as this are often superficial, formulaic, and contrived.

Many artists, however, place great emphasis on developing rich and complex decorative qualities in their work. Decorative imagery can be used to celebrate the unique satisfactions that the visual arts may offer. See *Pattern and Decorative painting*

derivation making art in such a way that influential source material is acknowledged and then transformed. Derivative work often results from a thoughtful analysis of images created by others and

FIGURE 49 A Normal Cat Form and Two Distortions.

the use of that analysis as a springboard for the creation of new art.

Derivation is distinguished from APPROPRIATION by the attitude and intent of the artist. As an approach, derivation generally places a greater emphasis on the creative conversion of the original source material than does appropriation. Derivation typically does not imply the irony associated with appropriation.

designer's colors opaque, water-based paints, usually GOUACHE.

digital literally made up of numbers. Digital information or imagery is material represented by 1s and 0s in computer files.

digitization the mechanical conversion of an image or TYPEFACE into DIGITAL form to enable processing by a computer or transmission over a network.

FIGURE 50 Christo, *Wrapped Automobile*, 1984, lithograph with collage element, 22″ × 28″. Landfall Press, Inc., Publisher. Courtesy of Landfall Press.

diptych a PAINTING created on two separate panels and meant to be viewed as a single unit. A diptych may be composed as a single, harmonious whole, or the artist may use the diptych form to reinforce the juxtaposition of two images contrasting in form or CONTENT.

display type TYPE that is larger in size and/or weight than other type with which it is paired. In book design, display type frequently is used for titles or headings in order to set these words apart from the main text, which would be set in COMPOSITION SIZE.

distortion the alteration of shape or shapes in a manner that changes internal relationships and relative PROPORTIONS between parts. Prominent distortions can introduce a SURREAL quality to an image. See Figure 49.

documentation images that record an artist's process and concepts. Documentation is often the only marketable product produced by CONCEPTUAL artists. The environmental artist Christo, a gifted and prolific draftsman, records his works in the form of DRAWINGS, prints, and films (Figures 50 and 51).

drawing the act, technique, or product of creating an image using PIGMENT in a solid as opposed to fluid BINDER. Common MEDIA for drawing include CHALK, CHARCOAL, GRAPHITE, and SILVERPOINT.

FIGURE 51 Christo, *Wrapped Museum of Contemporary Art*—Chicago, lithograph collage, 24″ × 32″. Landfall Press, Inc., Publisher. Courtesy of Landfall Press.

Drawings often are defined by the interaction of linear elements. For this reason, images created with fluid media, such as ink, may be referred to as drawings if they have strong linear qualities.

drypoint an INTAGLIO technique in which the surface of the plate, usually a soft metal such as copper or zinc, is scratched directly with a sharp metal point. During the printing process, the ink is held in the rough burr raised by the steel needle, yielding a delicate linear image. The fragility of the burr limits drypoint to a relatively small number of impressions without loss of detail and clarity.

earth color brown. Earth colors are low INTENSITY, WARM colors. They originally were made from mineral pigments such as iron oxides or clays. Sienna was made from clay mined in Sienna, Italy, while the clay used for umber was mined in Umbria. When pure clay is ground and no further treatment is used, the resulting pigment is called "raw." If the clay is first heated to a temperature of several hundred degrees, the resulting lower-value pigment is called "burnt."

Common earth colors are raw sienna, raw umber, burnt sienna, burnt umber, and yellow ochre.

easel painting painting at a scale such that the perimeter of the SUPPORT is within the physical reach of the artist. The support is generally a stretched CANVAS or a rigid panel that may be easily moved by the artist. It is usually placed on an easel for painting.

Created at a personal and intimate scale, easel painting is distinguished from large-scale works that are conceived from the outset for display in museums or other public spaces.

egg tempera see *tempera*

encaustic a PAINTING MEDIUM, or a technique in which wax is the BINDER. In order to work with the encaustic, the medium is softened and colors are mixed on a hotplate or griddle. Contemporary artists working in encaustic often combine resins with the wax to increase the hardness and permanence of the finished piece. Encaustic allows the development of a distinctive luminosity and can suggest an almost tactile depth.

engraving an INTAGLIO printmaking technique in which the image to be printed is cut or scratched into the printing plate with a sharp tool.

etching an INTAGLIO printmaking technique in which acid is used to cut the image to be printed into the printing plate. The image is controlled by the use of a RESIST, which protects areas of the plate from the acid. The term also refers to a print made by this technique.

Expressionism, German originating at the beginning of the twentieth century, this movement stressed that art must respond to inner necessities, to the subjective and obsessive psychological demands of the individual. In contrast to such artists as the FAUVES, who worked from a more psychologically tempered point of view, the German Expressionists employed strident color and distorted forms as metaphors for their inner turmoil. While NONOBJECTIVE painting was an outgrowth of the later years of the movement, the artists of the early years worked with REPRESENTATIONAL imagery, most often based on human situations and interactions.

Artists associated with the movement include those of DIE BRÜCKE and the BLAUE REITER.

expressionistic a term used to describe work that conveys a sense of the emotional involvement of the artist and his or her personal responses to subject matter or media. Expressionistic work is character-

ized by the intensity of its presentation. Joan Mitchell's *Hemlock* (Figure 52) offers expressionistic qualities through the velocity and energy of her bold strokes of paint.

Fauvism an early-twentieth-century French art movement characterized by the expressive effects of stri-

FIGURE 52 Joan Mitchell, 1926–1992. *Hemlock*, 1956. Oil on canvas, 91″ × 80″ (231.1 cm × 203.2 cm). Purchase, with funds from the Friends of the Whitney Museum of American Art. Collection of Whitney Museum of American Art, New York.

FIGURE 53 Henri Matisse (French, 1869-1954), *Blue Nude* ("Souvenir De Biskra") (1907), oil on canvas, 92.1 cm × 140.4 cm. The Baltimore Museum of Art: The Cone Collection, formed by Dr. Claribel Cone and Miss Etta Cone of Baltimore, Maryland.

dent COLOR frequently applied with bold, free brushwork. The word "fauve," which literally means "wild beast," was applied to the artists of the movement in criticism of their violent distortions of form and crude juxtapositions of intense color.

Henri Matisse (Figure 53) was the most influential Fauve. Others associated with this relatively small group were André Derain, Maurice Vlaminck, and Georges Rouault.

figurative depicting or suggesting animate beings. The term is used frequently to refer to imagery based on the human body.

figure/ground the relationship between what is perceived as object or subject and background or context. In Sheila Asbell Allen's painting (Figure 54), the object or subject is understood as the female figure and the pole to which she gracefully clings. The ground or background, however, occupies the largest proportion of the composition.

What we see as figure and what we see as ground are determined by a complex set of perceptual principles studied in depth by the GESTALT psychologists. Foremost among these principles is the desire of the mind to understand visual phenomena as simply as possible. In order to do this, we rely on a number of visual clues to direct our attention to that which is figure or foreground in our perceptual environment and filter out that which is background. There can be a complex relationship between figure and

FIGURE 54 Sheila Asbell Allen, *Mast*, 1995, acrylic on canvas, 16″ × 12″. Courtesy of the Artist.

ground as in Jean Dubuffet's example (Figure 55) where figure/ground relationships shift throughout the composition.

film color the perceived effect created when an object is illuminated by light of a single HUE, causing the object to appear as if it were being viewed through a colored film. Film color describes the effect of light on a white house at sunset. The LOCAL COLOR of the house is altered by the sunset, which gives it a pink PERCEIVED COLOR.

flat shallow PICTORIAL SPACE. Flat images have a "pulled to the surface" quality, which is often accompanied by the use of unmodulated color and the

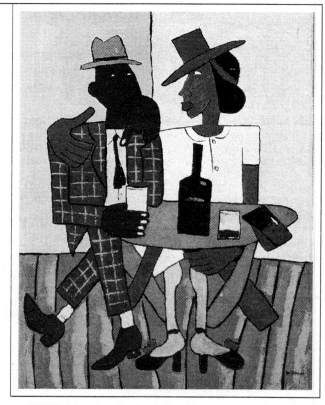

FIGURE 56 William H. Johnson, *Cafe*, ca. 1939-40, oil on paperboard, 36½″ × 28⅜″. Art Resource, N.Y.

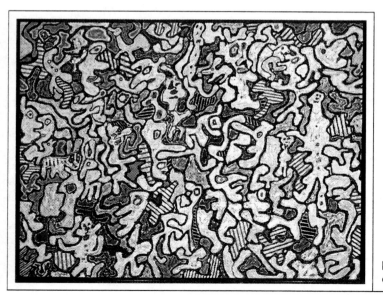

FIGURE 55 Jean Dubuffet, *Vertu Virtuelle* (Virtual Virtue), 1963, oil on canvas, 37¾″ × 50⅞″. Fondation Beyeler, Riehen/Basel.

absence of modeling. In William H. Johnson's *Cafe* (Figure 56) a witty use of overlapping shapes creates pattern and suggests an artificially shallow space.

focal point the perceived focus of interest; the visual center of an image. A focal point may be explicit, as in Michael Nakoneczny's painting (Figure 57) in which the woman placed in the center of the composition commands immediate attention. A differing approach may be found in Jackson Pollock's *Number 25* (Figure 11), where each area of the painting receives essentially an equal visual emphasis and the focus is diffused.

folk art art produced by artists having little or no formal academic training. Folk art typically is highly stylized and is associated with a specific social context. It relates to a tradition that has evolved over time, passed from generation to generation. It often has a direct and unschooled appearance that makes it, like PRIMITIVE ART, an attractive source for professionally trained artists. Folk art is distinct from NAIVE ART in that naive art, while it

FIGURE 57 Michael Nakoneczny, *Flesh Fire*, acrylic on Masonite, 1985, 23½″ × 30½″. Courtesy of the artist.

may be similar to folk art in appearance, is associated with a personal and individual vision. The folk artist's work is bound to the standards or demands of his or her society, while the naive artist generally acts as an individual.

font a full assortment of TYPE of one STYLE and size, including upper and lower case letters of the alphabet, including these letters in ITALIC and BOLD FACE, numerical figures, and punctuation marks.

foreshortening the compression and adjustment of proportion required to NATURALISTICALLY represent in two dimensions objects that are receding in space. In George Luks's *The Wrestlers* (Figure 58), foreshortening is employed in the rendering of the torso of the pinned athlete.

FIGURE 58 George Luks, *The Wrestlers*, 1905, oil on canvas, 48¼″ × 66¼″. Courtesy, Museum of Fine Arts, Boston. Charles Henry Hayden Fund.

form the general structure and organization of an image or part of an image. Form refers primarily to SHAPE, but also to COLOR, TEXTURE, and manner of representation.

formal pertaining to the visually perceived qualities of a work of art, independent of issues of CONTENT or meaning. when we discuss the formal characteristics of a work of art, we are concerned with the FORMAL ELEMENTS and their interaction.

formal elements the elements that contribute to the visual structure of an image: COLOR, LINE, SHAPE, SPACE, TEXTURE, and VALUE.

format the dimensions or proportions of a two-dimensional image. In photography, format refers to the size of the film (e.g., 35mm, 2 x 2, 8 x 10, etc.). In other two-dimensional work, it refers to the size of the finished piece and its orientation (i.e., horizontal or vertical).

Format is a primary design decision, and all compositional choices are affected by it. See also *scale*; *proportion*

found object a translation of the French "objet trouvé." Found objects are natural or manufactured forms, in whole or in part, selected by an artist and presented as art.

framing see *cropping frame*

fresco a MURAL painting technique in which PIGMENT suspended in limewater is painted directly onto plaster built up on a wall. Because the pigment penetrates into the wet plaster rather than simply adhering to the surface, fresco is exceptionally stable.

Freudian pertaining to the psychoanalytic theories of Sigmund Freud. Freud's theories traced neurotic behavior to psychic traumas, real or imagined, early in life. He developed the technique of free association to bring repressed information out of the unconscious mind. Freudian theory presents an image of humans as bundles of instincts, driven by sexual energy. Freud introduced models of the mind divided into the conscious and the unconscious, and the personality divided into the ego, superego, and id.

In *The Interpretation of Dreams*, published in 1900, Freud emphasized the symbolic meaning of dreams as a key to the unconscious. His lectures and writings had a profound influence on modern thought, but as his ideas were popularized they became distorted. It became common to look for hidden symbolic or sexual meaning everywhere.

A Freudian interpretation is frequently applied to art and can serve to explain the meaning of SYMBOLS and dream or sexual imagery. SURREALIST painters sought to illustrate the unconscious mind in their art and employed symbols as described by Freud.

frisket a STENCIL. Available in many forms, frisket paper is used with AIRBRUSH, and a liquid frisket often is used with watercolor.

frontal a point of view in which the represented objects are shown directly facing the viewer. Objects are

placed parallel to the picture plane rather than receding in space. A frontal presentation tends to flatten the image, as in Ed Paschke's portrait of Lincoln (Figure 59).

Futurism an Italian movement, 1909–1914, that focused on subjects of the industrial age, science, mechanical power, and urban life. Futurism was influenced by the brilliant color and separated brushstrokes of NEO-IMPRESSIONISM, the faceted

FIGURE 59 Ed Paschke, *Anesthesio*, 1987, oil on linen, 68" × 80". Courtesy of the artist and Maya Polsky Gallery, Chicago. Photo by William H. Bengston.

FIGURE 60 Umberto Boccioni, *The City Rises*, 1910, oil on canvas, 6' 6½" × 9' 10½". The Museum of Modern Art, New York. Mrs. Simon Guggenheim Fund. Photograph © 1999 The Museum of Modern Art, New York.

forms of CUBISM, and the stop-action effects of sequential high-speed photography. The movement was launched by a literary manifesto that glorified brute power and called for the destruction of the art forms of the past. Visual artists responded with their own manifesto, demanding new subject matter that would effectively address the drama of a modern industrialized urban environment. They called for others to join them in the search for an art of a new immediacy and intensity that would trigger dynamic sensations of light, color, and sound. Foremost among the Futurists were Umberto Boccioni, (Figure 60), Giacomo Balla, and Gino Severini.

genre painting painting representing everyday life and activities. The nineteenth-century academies considered genre a distinct subject category for painting, as was landscape and portraiture.

geometric primarily angular in appearance; having reference to simple geometric forms such as circles, triangles, rectangles, or other regular shapes or angles. Geometric often is contrasted with ORGANIC.

geometric harmony a HARMONY of COLOR that results from overlaying a COLOR WHEEL with a regular polygon (such as a triangle, square, pentagon, or hexagon) and building a composition of the HUES indicated by the points of the shape. Geometric harmonies include TRIADIC HARMONY, QUADRATIC HARMONY, and so on (Figure 61).

gesso a white GROUND used for painting or for drawing with SILVERPOINT. Traditionally, gesso was a combi-nation of glue and powdered plaster and was used to prepare wooden panels for painting. In contemporary times it most often refers to an acrylic POLY-MER-based primer that is used to prepare canvas. The function of gesso is to seal and stabilize the SUPPORT and to provide a uniform painting surface.

Gestalt psychology a school or branch of psychology developed in the 1920s and 1930s. Gestalt is a German word meaning "form" or "structure." Gestalt psychology holds that patterns can only be understood as unified wholes and that a whole cannot be understood solely by examining the parts of which it is composed. The belief that a whole is greater than the sum of its parts is at the core of Gestalt psychology.

The Gestalt psychologists were particularly interested in visual perception and sought to understand the means by which FIGURE/GROUND relationships are deciphered. A distinction is drawn between those

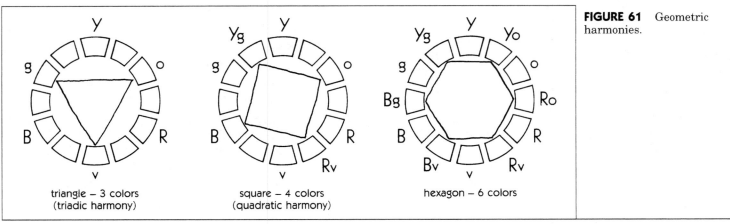

FIGURE 61 Geometric harmonies.

triangle – 3 colors
(triadic harmony)

square – 4 colors
(quadratic harmony)

hexagon – 6 colors

events that are attended to, the perceptual foreground, and their environment, the perceptual background. Gestalt thinking explores the means by which we distinguish subject from background in perceptual experience.

A fundamental principle of Gestalt psychology states that we will perceive an image as complete as possible, simplifying a complex pattern of multiple parts in order to deal with it as a unified whole. For example, a dotted line is understood as a line, not as a row of independent and unrelated dots.

Artists are particularly interested in Gestalt psychology as it offers a model for understanding the mental process of forming patterns and translating two-dimensional patterns into recognizable images.

gesture refers to the expressive and evocative qualities of an image. A gestural line or stroke conveys the intensity of its creation and makes a direct reference to the movement, pressure, and deliberateness of the drawing or painting process. Gesture is expressive of the artist's relationship to both subject and medium, and captures and reveals the quality of a moment. Spontaneous gesture can be EXPRESSIONISTIC, conveying an immediate and intuitive manner of working, while a more contained gesture may suggest a staid, methodical approach.

Both Willem de Kooning (Figure 8) and Jackson Pollock (Figure 11) are described as gestural painters. Their works convey an intense personal involvement in the painting PROCESS and have a freedom and breadth that conveys to the viewer the urgency with which the paint was applied to the canvas.

gesture drawing a manner of drawing in which the artist seeks to capture the activity of an animate being. In contrast to CONTOUR DRAWING, where the lines carefully follow the edges of forms, the lines in a gesture drawing are animated and track the AXIS of the form. Gesture drawings may have a scribbled appearance resulting from the artist's concentration on rendering the dynamic qualities of a figure in action, its weight and movement, rather than its strict visual appearance (Figure 62).

golden mean a proportional relationship between two elements where A/B = B/A + B. This ratio is .618 to 1, or approximately 5 to 8. The golden mean, or golden section as it is sometimes known, was recognized in antiquity as an ideal standard of proportions (Figure 63). Proportional relationships corresponding to the golden mean are found throughout nature (in forms such as seashells and pine cones) as well as in many works of art and architecture. Seurat employed the golden mean in composing *A Sunday Afternoon on the Island of the Grande Jatte* (Figure 87).

gouache opaque WATERCOLOR, made by the addition of whiting or clay to the PIGMENTS.

graffiti drawings, paintings, and/or text emblazoned upon public buildings or other publicly visible structures. As an act of vandalism, graffiti often has a social or political component that extends beyond the artist's individual need for self-expression.

Artists such as Keith Haring and Kenny Scharf (Figure 124) have been influenced by the energy of contemporary urban graffiti.

graphic design art created according to the needs or specifications of a client as a means of communicating or promoting a concept, product, text, or service. Graphic design images frequently are created with the intention of being reproduced for a mass audience.

graphite a greasy, dark-gray form of carbon. Graphite is mixed with clay to make the "lead" of pencils. Powdered graphite also may be used as a dry pigment or in paints.

gray scale see *value scale*

grid a pattern that divides a pictorial format with crossing lines. Grids are usually formed from hori-

FIGURE 62 Judith Baker, untitled, 1998, *Conté crayon,* 24″ × 18″. Courtesy of the artist.

FIGURE 63
A golden rectangle.

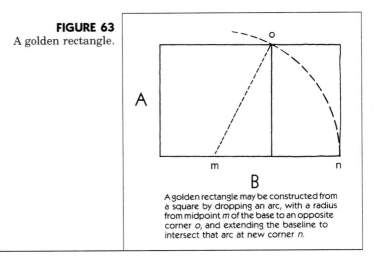

A golden rectangle may be constructed from a square by dropping an arc, with a radius from midpoint *m* of the base to an opposite corner *o*, and extending the baseline to intersect that arc at new corner *n*.

zontal and vertical lines, but many variations are possible (Figure 64). A grid can provide an underlying structure for the organization of a complex visual image. In addition, a grid may reinforce the rectangularity of the format or provide a backdrop in front of which the image is organized.

For graphic designers, preprinted grid sheets may be used as aids in setting margin widths, establishing picture placement, and in general establishing a rigid structure within which to assign any array of TEXT and IMAGERY (Figure 65).

The use of the grid as a basis for graphic design became popular with the Swiss Style, which evolved in Switzerland in the post–World War II era par-

FIGURE 65 Text and imagery combined on a grid sheet.

FIGURE 64 Various grids.

tially under the influence of the GEOMETRIC styles promoted at the BAUHAUS in Germany.

grouping principles those principles called by GESTALT psychologists *Pragnanz* or "unit-forming" principles, which describe the ways the mind simplifies visual arrays by gathering them into units.

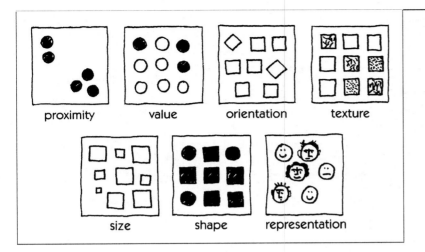

FIGURE 66 Grouping principles.

The fundamental grouping principles are proximity and similarity. We tend to relate objects to one another based on their shared visual characteristics or their relative placement within an image.

When confronted with a complex situation, composed of many parts, the mind seeks to simplify the task of understanding the situation by gathering the parts into groups. Just as when watching a football game we tend not to observe twenty-two individual players, but rather simpler groups like offense and defense or backfield and line, so also in looking at art we make an effort to gather discrete visual parts into more coherent wholes.

In our efforts to make sense out of complex visual images, we seek similarities in the visual characteristics of various components of an image. Elements may be grouped by similarities in HUE, VALUE, INTENSITY, SHAPE, size, texture, or orientation. In addition, elements may be grouped by similarity of representation (Figure 66).

grisaille a painting done in tones of gray.

halftone a printing process (or the result of the process) in which gradations of TONE are translated into a continuous system of minute dots. This photochemical process facilitates clarity in commercially printed photographs and other images.

harmony the relationship between two parts of an image. Harmonies result from intervals, distances, and contrasts. In visual art, as in music, harmony describes relationships between events and is created by intervals or degrees of contrast. Harmonies most often describe color relationships (see *analogous harmony*; *complementary harmony*; *geometric harmony*), and just as music requires at least two notes sounding simultaneously for there to be

harmony, so visual art requires at least two colors or other stimuli. Henri Matisse (Figure 67) excelled in creating harmony through the interplay of color and form, and shape and contour.

hatching see *cross-hatching*

hot press a method of making paper or board by subjecting it to extreme pressure and steam, yielding an especially smooth or slick surface sometimes referred to as "plate" or "high" surface. Hot-press papers are less absorbent and have less tooth, or texture, than COLD-PRESS papers.

hue the dimension of a COLOR that describes its location on the circumference of the COLOR WHEEL, indepen-

dent of its INTENSITY or VALUE. Hue is distinct from intensity, which describes its saturation, and from value, which describes the lightness or darkness of a color. Pink and red have the same hue, as do orange and rust or yellow and butterscotch. Hues are described as red, yellow, blue, orange, green, purple, or some combination, such as blue-green.

Brown is not a hue; neither is olive-green. Brown and olive-green describe hues at reduced intensity. Brown is a low-intensity yellow or yellow-orange, and olive-green is a low intensity yellow-green.

iconic having symbolic CONTENT or meaning. Iconic images convey meaning through explicit SYMBOLS

FIGURE 67 Henry Matisse, French, 1869-1954, *Bathers by a River*, oil on canvas, 1909, 1913 and 1916. 259.7 cm × 389.9 cm. Charles H. and Mary F. S. Worcester Collection, 1953.158. © 1998. The Art Institute of Chicago. All Rights Reserved. © Succession H. Matisse, Paris/Artists Rights Society (ARS). New York.

that are understood by the artist. Artists often rely on conventionalized symbols that are intended to impart specific meaning to the viewer.

iconography the study of the total meaning of a work of art and how the FORM of the work conveys its meanings. Iconography goes beyond the subject matter of an art object, considering it within its total cultural context and examining it as an expression of the worldview of its maker. Iconography relates to the investigation of the meanings conveyed through the merger of form and CONTENT.

Traditionally, especially with religious art, iconography has been concerned with the interpretation of SYMBOLS that conveyed specific meanings in particular times and places, even though those meanings may since have been altered or eradicated.

ideation in creativity theory, the process of generating ideas; brainstorming.

installation work that physically extends beyond what otherwise would appear to be the parameters of an individual painting and/or sculpture. Installation in general usage suggests a large FORMAT ASSEMBLAGE, which may or may not be permanent in nature. Installations are erected in either interior or exterior spaces, and they may be site specific or not.

illustration an image used primarily to illuminate, convey information about, or draw attention to a subject apart from the image itself.

Graphic designers use illustration for purposes of narration or clarification. Illustration in this context may include images as diverse as political cartoons and medical diagrams.

The key distinction between illustration and fine art is the manner in which it is used. When a tobacco company used Rembrandt's *The Syndics of the Cloth Guild* as part of the trademark for Dutch Masters cigars, they used the painting as an illustration. Larry Rivers's work (Figure 68), with the APPROPRIATED image of the cigar box, stands alone and is not an illustration.

FIGURE 68 Larry Rivers, *Dutch Masters I*, 1963, oil on canvas, 40″ × 50″. Cheekwood Museum of Art, Purchased with funds from the National Endowment for the Arts, a federal agency, and matching funds from local donors.

illustration board art paper mounted on a stiff core, usually layered cardboard. Illustration board is widely used in commercial art but may not be suitable for permanent images because of the acid content of the underlying cardboard.

FIGURE 69 Claude Monet, French, 1840-1926, *On the Bank of the Seine, Bennencourt* (Au Bord de l'eau, Bennencourt), oil on canvas, 1868, 31⅞″ × 39½″ (81.5 cm × 100.7 cm). Mr. and Mrs. Potter Palmer Collection, 1922.427. Photograph courtesy of The Art Institute of Chicago.

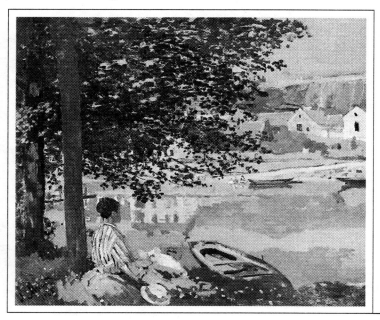

imagery those figures, objects, or things that are the focus of attention within a picture; what is depicted. The imagery an artist employs can be a unifying factor in his or her BODY OF WORK.

impasto in painting, a built-up, textural surface created with thickly applied paint. Impasto conveys an awareness of the physical quality of the paint and the hand of the artist.

Impressionism a late-nineteenth-century movement originating in France. Impressionism emphasized the optical appearance of the visible world. Impressionist artists sought to capture fleeting visual sensations and were particularly responsive to light and atmosphere. Their paintings are characterized by broken brushwork, softly defined forms, and color saturated by light.

Like the Realist painters before them, the Impressionists painted commonplace subjects from their everyday lives and immediate surroundings. The new availability of oil paint in tubes enabled the Impressionists to paint outside, directly from nature. This resulted in a strong emphasis on landscape and imbued their works with a freshness and spontaneity that distinguished them from works created entirely in the studio.

Among the artists associated with Impressionism are Gustave Caillebotte (Figure 74), Mary Cassatt, Edgar Degas (Figure 22), Claude Monet (Figure 69), Berthe Morisot (Figure 23), Camille Pissarro, Auguste Renoir, and Alfred Sisley.

FIGURE 70 Paul Wonner, *Imaginary Still Life with Slice of Cheese,* 1977, acrylic on canvas, 70″ × 40″. Collection of Mr. and Mrs. John Berggruen, San Francisco.

informal balance approximate BALANCE achieved by the placement of objects of similar visual weight in arrays that approximate SYMMETRY but are not symmetrical. Paul Wonner's still life (Figure 70) is an extreme example of informal balance. The objects are distributed about a central point, the plum, with a sense of almost equal weight. This radial organization contributes to a sense of vitalism in the picture, as it causes us to seek balance not only across the vertical axis, but along the whole array of diagonals as well.

intaglio the family of PRINTMAKING techniques in which the image to be reproduced is cut into the plate. In order to print, the plate is inked, and the surface is then wiped clean, leaving ink in the cuts. The press forces the paper into the cuts to pick up the ink. Common intaglio techniques are DRYPOINT, ENGRAVING, and ETCHING.

intensity the dimension of COLOR that measures the brilliance, saturation, or colorfulness of a HUE. The closer a color is to its pure state, the higher its intensity. The lower the amount of hue in a color (the closer it is to gray), the lower its intensity. In mixing colors, either additively or subtractively, intensity is reduced by mixing a hue with its COMPLEMENT.

Intensity can confuse our perception of VALUE. The brightness of a high-intensity, NORMAL VALUE red, blue, or purple may suggest that it is lighter or higher in value than a low-intensity brown of the

same value (Figure 71). Intensity is sometimes referred to as chroma or saturation. See *additive color*, *subtractive color*

isometric perspective a form of PERSPECTIVE drawing in which parallel lines receding into space do not converge at a vanishing point, but remain parallel. Additionally, proportional relationships between line lengths are maintained. Isometric perspective is used most frequently by engineers and architects to create "measured perspective." In such cases, their drawings resemble a TWO-POINT PERSPECTIVE without VANISHING POINTS, with the receding base lines always at a thirty-degree angle to the horizontal (Figure 72).

Isometric perspective is sometimes referred to as oriental perspective, because traditional methods of drawing in Asia do not use the Renaissance model of LINEAR PERSPECTIVE.

italic a TYPE form in which each letter is inclined to the right of its center. Setting words in italics separates them from the main body of the TEXT by creating an emphasis on their presence.

Jugendstil German for "youth style." Jugendstil was a German variant of ART NOUVEAU.

Jungian pertaining to the theories of Carl Gustave Jung. After studying with Sigmund Freud, Jung developed an understanding of personality shaped by two com-

hue	high intensity	low intensity
RED	fire engine	brick
YELLOW	lemon	manila envelope
green	grass	olive

FIGURE 71
Hues at high and low intensity.

FIGURE 72
Isometric perspective.

no vanishing point

ponents: the personal incidents of an individual's life and the submerged historical memory of all peoples, which he called the collective unconscious. Beginning in the 1930s, artists responded to Jung's writings and were struck by his emphasis on myth and archetypes, symbols that originate in the collective unconscious and transcend a single time or culture. Jung's theories held significance for artists active in the later years of the SURREALIST movement and for the ABSTRACT EXPRESSIONIST generation. See also *Freudian*

layout the general arrangement of text and/or imagery in a design. A layout may be developed starting with a THUMBNAIL SKETCH, then refined to a detailed, final design.

The term also refers to the process of arranging elements in a design.

line that element of form which is characterized by length and direction. When a line becomes too broad

FIGURE 73 Various types of line.

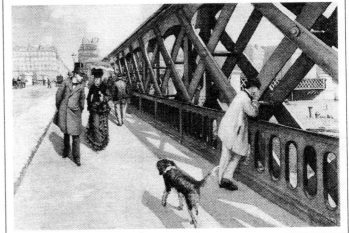

FIGURE 74 Gustave Caillebotte, *Le Pont de L'Europe*, Huile sur toile. 125 cm. × 180 cm. Signé situé Paris et daté 1876 en bas a dr. 1876. Musée du Petit Palais, Geneva.

in relation to its length, it begins to assume the characteristics of a SHAPE.

Line quality may be widely varied and is responsive to the tool used to make it, the physical GESTURE with which it is drawn, its direction, its TEXTURE, and its interaction with adjacent lines and other formal elements.

Line may be the sole formal element in a drawing. It may be used as an outline to define CONTOUR or it may be used to model, as with the CROSS-HATCHING technique. Line may be thick or thin, soft or hard, flowing or ragged, smooth or irregular. It may be cool and objective or bold and expressive (Figure 73).

linear perspective describes those methods of creating an illusion of depth, first applied in Europe during the Renaissance, which rely on the principle that parallel lines receding into space appear to converge at a VANISHING POINT (see Figures 74 and 75).

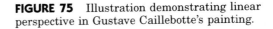

FIGURE 75 Illustration demonstrating linear perspective in Gustave Caillebotte's painting.

See also *one-point perspective; two-point perspective; three-point perspective*

line drawing by strict definition, a drawing that is created exclusively through the use of line, without areas of contrasting VALUE (Figure 76). In general usage, the term relates to drawing that emphasizes line, even when the density of linear pattern creates contrasting areas of value (Figure 77).

line of sight the implicit LINE along which the vision of a figure in an image moves. Just as you will be

FIGURE 77 John Ekstrom, *Riverside, California*, 1998, colored pencil, 11″ × 14″. Courtesy of the artist.

FIGURE 76 John Storrs, American, 1885-1956, *Woman with Hand on Chin*, 1931, silverpoint on paper, 13″ × 8″. The Arkansas Arts Center Foundation Collection: Donation Box Acquisition Fund, 1985. 85.55.

tempted to look up if you walk into a room where everyone is looking at the ceiling, so an artist can direct our attention within a picture by directing the attention of individuals within the picture.

Elizabeth Catlett uses this device in her print (Figure 78) to establish a conceptual FOCAL POINT outside the physical confines of the SUPPORT.

linocut a RELIEF printmaking technique in which the image to be printed is cut into a linoleum surface. Typically the linoleum surface is adhered to a block of wood before the image is cut. A linocut (as in

Figure 78) often exhibits an interplay of textures comparable to a WOODCUT.

lithography a printmaking technique that relies on the principle that oil and water do not mix. A lithography plate, traditionally limestone, is highly polished and then drawn on with a greased-based medium in the areas that are to print. The stone is then lightly etched with acid, the grease-based medium serving as a RESIST. The areas that have been drawn upon retain their polish, while the exposed areas of the stone become porous.

During the printing process, the stone is first wetted. Water runs away from the polished areas of the plate just as it runs off a highly waxed car, while the areas of the plate that have been etched hold the water. The oil-based ink, applied with a roller, adheres to the drawn surfaces on the stone (Figure 79).

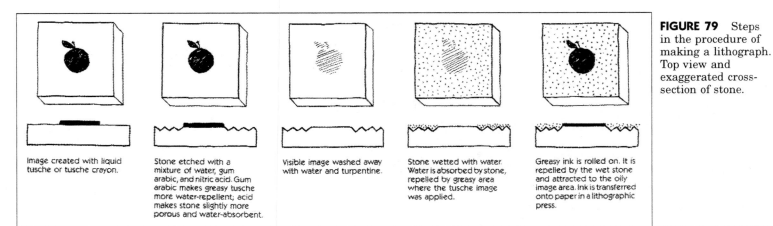

Image created with liquid tusche or tusche crayon.

Stone etched with a mixture of water, gum arabic, and nitric acid. Gum arabic makes greasy tusche more water-repellent; acid makes stone slightly more porous and water-absorbent.

Visible image washed away with water and turpentine.

Stone wetted with water. Water is absorbed by stone, repelled by greasy area where the tusche image was applied.

Greasy ink is rolled on. It is repelled by the wet stone and attracted to the oily image area. Ink is transferred onto paper in a lithographic press.

FIGURE 79 Steps in the procedure of making a lithograph. Top view and exaggerated cross-section of stone.

Maurie Kerrigan's *¿Snow Dog?* is an example of a lithograph (Figure 80). See also *offset lithography*

local color the actual color of an object in normal daylight, as opposed to PERCEIVED COLOR. For example, the local color of a white house is always white; seen at sunset, it might appear red or purple.

mat a protective frame made from a quality cardboard. A mat serves two functions. First, it visually completes an image, separating it from the out-

side world and providing a bridge between objective reality and the work of art itself. A highly colored mat will have an active effect upon the artwork and its surroundings and, unless this is desired, a neutral and unobtrusive color generally is preferred.

Second, a mat protects the surface of an image by creating a raised border around it. If framed under glass, the mat serves to lift the glass off the work of art.

There are many ways to construct a mat, but one

FIGURE 80 Maurie Kerrigan, *¿Snow Dog?*, 1982, lithograph, 22″ × 30″. Private Collection.

FIGURE 81 Hinged mat.

of the most professional is a hinged mat (Figure 81), which provides a rigid back for the artwork, easy access to the image, and requires a minimum of attachment to the artwork itself. Mats and backings should be made from high-quality, acid-free board to protect the artwork from oxidation and deterioration.

measured perspective see *isometric perspective*

mechanical see *artwork*

media plural of MEDIUM

medium (1) the general technique or method by which an image or art object is made; for example, PAINTING, DRAWING, or ENGRAVING. In this usage the plural form is media.

(2) the specific material or technique used in the making of an image or an art object; for example, WATERCOLOR, colored pencil, CONTÉ CRAYON, or GRAPHITE. In this usage the plural form is media.

(3) the specific recipe or mixture of BINDERS and solvents used to thin and extend paint and to control its manipulative qualities. In this usage the plural form is mediums.

metamorphosis a change from one formal configuration into another. In art and design, metamorphosis emphasizes the process of change and the intermediate or transitional stages between two FORMAL states.

Minimal Art a movement that originated in the early 1960s and stressed a simple, direct expression of materials. Minimal Art is self-referential in that it emphasizes the visual sensation of the image itself, outside of any representational or metaphorical

FIGURE 82 Ellsworth Kelly, *Running White*, 1959, oil on canvas, 7′4″ × 68″ (223.6 cm × 172.7 cm). The Museum of Modern Art, New York. Purchase. Photograph © 1999. The Museum of Modern Art, New York.

associations. It is reductive in its disciplined organization of a small set of FORMAL elements. Minimalist paintings generally offer broad expanses of flat color with limited juxtapositions of FORM and COLOR contrasts, avoiding any suggestion of illusion or representation of the external world. They are impersonal in execution, simple, and objectlike.

In the early years of the movement, influential Minimal paintings were created by Ellsworth Kelly (Figure 82), Brice Marden, and Frank Stella.

modeling the use of VALUE gradation to suggest the illusion of solidity. Modeling may be arbitrary and done in a manner that does not mimic nature, as in the work of Roger Brown (Figure 13), or naturalis-

tic, as in René Magritte's image of a pipe (Figure 131).

modern art the term usually designates art of the late nineteenth and twentieth centuries, though some historians consider the modern era to have begun in the late eighteenth century. In its most narrow usage, modern art refers to art created in the time period of late IMPRESSIONISM and POST-IMPRESSIONISM to the end of World War II and the era of ABSTRACT EXPRESSIONISM, or from about 1880 to 1945. In common usage the term modern art also includes CONTEMPORARY ART.

module a visual unit used repetitively as a "building block" to create a PATTERN or total visual structure. The elegant rows of script in Charles "Chaz" Bojorquez's *Placa / Rollcall* (Figure 83) are formed of individual modules or letter units.

monochromatic composed of a single HUE. A monochromatic image is one made using only COLORS of the same hue. Variety may be introduced only by variations in VALUE and INTENSITY.

monoprint see *monotype*

monotype a unique print made by PAINTING or DRAWING directly on the plate. Because the image is not part of the plate, it changes each time a print is made or pulled from the plate. Monotype combines the immediacy and uniqueness of a painting with the FLAT surface quality of a print.

motif a distinct GESTURE, FORM, PATTERN, IMAGE, or subject, repeated in an individual work or throughout a BODY OF WORK. Mark Rothko's hovering rectangles (Figure 9) are a motif that provides a visual

FIGURE 83 Charles "Chaz" Bojorquez, b. 1949, *Placa / Rollcall*, 1980, acrylic on canvas, 68¹⁄₄″ × 83¹⁄₈″. Art Resource, N.Y.

and thematic link throughout his mature works. Roger Brown makes pronounced use of repeated motifs with silhouetted figures and striated clouds in his CANVASES (Figure 13).

movement a discernible trend or direction in art, characterized by a shared body of thought and often by shared stylistic tendencies. A particular STYLE or set of visual characteristics may typify a movement, but style alone generally is not enough to define a movement. Like political movements, art movements

exist in a discrete period of time and are founded on conceptual issues.

multiple format a pictorial organization that combines two or more distinct COMPOSITIONS, with clearly defined BORDERS or limits, to create a total image.

The simplest forms of multiple FORMAT are the DIPTYCH and the TRIPTYCH.

Anna Marie Watkin's painting (Figure 84) is much more complex and reveals various ways in which the juxtaposition of multiple formats can become a dominant factor in the organization of a work of art.

multiple point of view the depiction of a scene from several points of view within a single image. The Starn twins' photographic assemblage (Figure 35) offers multiple points of view, through photographs shot from multiple vantage points.

Munsell system a system of COLOR notation devised by Albert F. Munsell. The system was first proposed in 1915 and defines color in terms of HUE, VALUE, and chroma (INTENSITY). See *value scale*

mural a large PAINTING or DRAWING created on or mounted flush with an interior or exterior wall. A mural often is integrated with and responsive to the architectural structure where it is situated.

Because of their size and location and their ability to address a large audience, murals often have been vehicles for the expression of political, social, and cultural beliefs. In this century American

FIGURE 84 Anna Marie Watkin, *Black Circle*, 1992, oil and acrylic on wood, four separate panels, 15″ × 13″ combined. Private collection.

painters active with the Works Progress Administration during the depression era and Mexican painters active in the 1920s and 1930s saw mural painting as a means of inspiring the public, propagandizing achievements, and warning of ideological and philosophical threats to the common good.

Nabis from the Hebrew word "prophet." The Nabis were a group of young French artists including Maurice Denis, Paul Serusier, Pierre Bonnard, and Edouard Vuillard, who in the late nineteenth century became greatly attracted to the POST-IMPRESSIONIST painter Paul Gauguin. Gauguin's paintings, which have strong DECORATIVE qualities resulting from his use of bold, flat colors, impressed the Nabis as an alternative to the NATURALISM of earlier IMPRESSIONISM. The emphasis in many paintings by the Nabis is on subject matter that is mysterious or ambiguous, linking their work to the SYMBOLIST movement.

naive art the art of the untrained or untutored. "Naive" is used to describe the art of children or adults who have not received significant instruction in the visual arts.

Throughout the twentieth century, works by naive artists have been praised for their direct approach and freedom from ACADEMIC mannerisms. Many sophisticated artists, including Jean Dubuffet (Figure 55) have responded to the freshness and vitality of naive art and have welcomed its influence in their own paintings.

narrative art art that suggests or tells a story. Narrative art uses recognizable imagery to present the outlines of an event. As such, it involves the intellect of the viewer in a response not only to the appearance of the image, its STYLE, COMPOSITION, and FORMAL characteristics, but also to the events depicted and the possibilities that might precede or follow them. Narrative is a major aspect of the work of Roger Brown (Figure 13).

naturalism an attitude toward representation that involves the rendering of nature in a straightforward way, sensitive to the visually perceived world. Naturalism is a realistic approach to art making and has been the dominant tendency throughout much of the history of Western art. While naturalism and realism often are used interchangeably, the term should not be used to define the nineteenth-century movement REALISM.

negative shape shape created in the background of an image by the interaction of the CONTOURS of the POSITIVE SHAPES and the edge of the FORMAT (Figure 85). TENSION can be introduced into an image by balancing the interest between positive and negative shapes or by allowing the relationship of positive to negative shapes to shift within a given composition (Figure 55). See also *figure/ground*

Neo-Expressionism an international revival, first evidenced in the mid-1970s, of early-twentieth-century tendencies toward intense COLOR, bold DISTORTIONS, and GESTURAL brushwork in painting. Artists associated with Neo-Expressionism, however, generally chose to work in much larger FORMATS than their predecessors. Often Neo-Expressionist artists employed REPRESENTATIONAL imagery and NARRATIVE content.

Critical responses to Neo-Expressionism were mixed, with some celebrating the viable return to direct and instinctive means of working, and other writers asserting that the movement was retrogressive and without a relevant new CONTENT other than a rejection of MINIMALISM.

Artists associated with the movement include Anselm Kiefer in Germany and David Salle (Figure 103) and Julian Schnabel in the United States. See also *expressionistic*, *Postmodernism*

Neo-Geo a widely used abbreviation for Neo-Geometric, a term applied to a wide range of works first produced in New York City in the 1980s. The reference to geometry was particularly relevant to the synthetically colored paintings of Peter Halley (Figure 86). Halley's works superficially made reference to the abstract, geometric art of such historic figures as Piet Mondrian (Figure 121), but otherwise, according to the artist, addressed the institutional rigor of hospitals and prisons, as well as the complexities of contemporary communication networks.

Neo-Geo has come to describe work by a diverse number of artists including Ashley Bickerton, Jeff

FIGURE 86 Peter Halley (1953-), *Prison with Conduit*, 1981, acrylic, dayglo and roll-tex on canvas (two parts bolted). 54″ × 36″. Gift of the artist, Addison Art Drive. © Addison Gallery of American Art, Phillips Academy, Andover, Massachusetts.

FIGURE 85
Positive shape/ negative shape relationships.

Koons, and Allan McCollum, whose works do not make any direct reference to the history of modern abstract painting, but rather present an attitude of aloofness and even pessimism characteristic of

Halley's investigations of postindustrial culture. See also *Postmodernism*

Neo-Impressionism the term used to describe the stylistic tendencies of Georges Seurat (Figure 87) and his followers. Neo-Impressionist painters pur-

sued IMPRESSIONIST subjects including landscape and urban life. The light, airy COLOR of their PAINT-INGS is indebted to Impressionism as well. Seurat felt Impressionism to be too fleeting and suggestive of only a moment in time. In his own work, he

FIGURE 87
Georges Seurat, French, 1859-1891, *A Sunday on La Grande Jette—1884,* oil on canvas, 1884-86, 207.6 cm × 308.0 cm. Helen Birch Bartlett Memorial Collection, 1926.224. Photo courtesy of The Art Institute of Chicago.

sought effects of monumentality and timelessness. He was particularly interested in new scientific theories regarding color and perception, and, partly as a reaction against the more intuitive and casual use of color by the Impressionists, he applied these theories to his paintings. Seurat's paintings, as those of his followers, are characterized by POINTILLIST (divisionist) brushstrokes and rigidly structured COMPOSITIONS.

In addition to Seurat, artists associated with Neo-Impressionism include Henri-Edmund Cross and Paul Signac.

neutral color a color of low INTENSITY, such as beige, olive, rust, or mauve. In the COLOR WHEEL, neutral colors will be found at the hub, around the central gray (Figure 88). They are made by mixing a HUE with its COMPLEMENT or gray. Because they are composed of a balanced range of hues, neutral colors contrast less than colors of a higher intensity and are therefore useful in unifying the color scheme of a COMPOSITION.

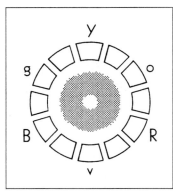

FIGURE 88 Location of neutral colors on a color wheel.

New Image Painting specifically a 1978 exhibition at the Whitney Museum of American Art. The show, which consisted of works by ten painters including Jennifer Bartlett and Neil Jenney, emphasized a widespread tendency evident beginning in the early 1970's throughout the United States that merged interests in the geometric emphasis of MINIMALISM with FIGURATIVE imagery.

Through time, the term "new image painting" has come to refer to a range of figurative painting done in a schematic or even cartoonlike manner.

newsprint a relatively inexpensive, off-white paper made from wood pulp and recycled paper. Newsprint is available with a rough or smooth surface and is attractive for studies and SKETCHES because of its affordability. Due to its high acid content, newsprint is not a stable paper and will yellow and become brittle over time.

nonobjective not referring to objects. Nonobjective paintings do not represent objects or things. They are not abstractions of the seen world.

Nonobjective art is constructed solely through the interaction of FORMAL elements. It emerged during the 1910s as an effort on the part of artists to create a purely visual world free from direct representation of the external world. See also *abstract, Op Art*

nonrepresentational see *nonobjective*

normal value the VALUE of a HUE at its highest INTENSITY. The normal value of yellow is relatively high,

while the normal value of blue is relatively low (Figure 89).

objective color see *local color*

objective drawing DRAWING that represents and records the world as seen, without DISTORTION. In objective drawing there is an effort to maintain a point-for-point correlation between an existent external reality and the work of the artist.

oblique perspective see *isometric perspective*

offset lithography a method of printing favored for commercial purposes which utilizes the working principles of LITHOGRAPHY. In this process an image on a metal, paper, or stone plate is transferred to an inked rubber surface which in turn transfers the image to the paper on which it is being printed. The process allows long printing runs and crisp line quality or halftone images in black and white as well as color.

oil paint paint that uses a vegetable-based drying oil, usually linseed oil, as a BINDER for the PIGMENT. In addition to pigment and oil, oil paints may include additional agents to control drying. Among the advantages of working in oils is that COLOR does not change upon drying.

Another quality of oil-based paints is that the MEDIUM does not cause vegetable fibers to swell and shrink, so oil MEDIA can be used on paper GROUNDS without concerns of warping the surface. The oil medium, however, will penetrate the fibers of the paper, and there is danger of rotting if the SUPPORT is not properly prepared.

oil pastel a drawing material in which the PIGMENT is bound with a mixture of oil and wax, and produced in a stick or crayon form.

one-point perspective a system of LINEAR PERSPECTIVE that allows representation of rectangular solids oriented frontally, parallel and perpendicular to the

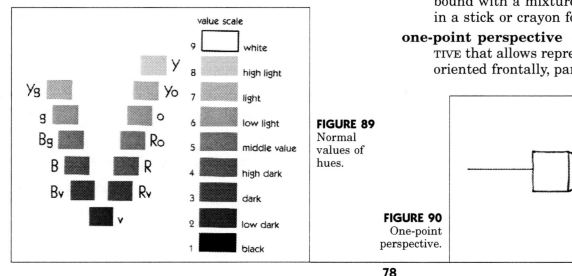

FIGURE 89
Normal values of hues.

FIGURE 90
One-point perspective.

PICTURE PLANE. One VANISHING POINT is established at the horizon for all LINES or edges which are receding in space, the ORTHOGONALS. Lines that are parallel to the viewer do not recede in space and so do not converge at a vanishing point (Figure 90).

Op Art short for "optical art." A movement originating in the mid-1960s in which perceptual shifts and ambiguities, such as illusions of depth or movement, are stressed. Op paintings trick the viewer into sensing motion or flux within the patterns of a flat, painted surface by presenting tightly rendered patterns and the vibration of color contrasts.

In the late 1980s and throughout the 1990s, a revival and reassessment of Op Art by such artists as Philip Taaffe stressed its decorative richness.

Among the major Op painters are Bridget Riley (Figure 91) and Victor Vasarely.

optical color see *perceived color*

organic an adjective used to describe abstract forms that are evocative of the world of nature. Organic imagery usually is characterized by flowing LINES and rounded shapes. Organic forms are often contrasted with GEOMETRIC forms, as in the work of Barbara Rossi (Figure 92).

oriental perspective see *isometric perspective*

FIGURE 91
Bridget Riley, *Current*, 1964, synthetic polymer on composition board, 58³/₈″ × 58⁷/₈″ (148.1 cm × 149.3 cm). The Museum of Modern Art, New York. Phillip Johnson Fund. Photograph © 1999 The Museum of Modern Art, New York.

FIGURE 92
Barbara Rossi, *A Lady Waiting for Dinner*, 1983, acrylic on Masonite, 45″ × 35⁷/₈″. Courtesy of the Phyllis Kind Gallery—New York. Photo by William H. Bengston.

orthogonals in ONE-POINT PERSPECTIVE, the lines perpendicular to the PICTURE PLANE, receding into space toward the VANISHING POINT.

outsider art art created for purposes that traditionally have been furthered outside the mainstream institutions of art schools, fine art galleries, and museums. Outsider art would include FOLK ART, NAIVE ART, and VISIONARY ART as well as works by children, the mentally ill, and criminals. Although outsider artists may have their creations shown in galleries and museums, typically they would not have sought out such venues for their work.

overlapping overlapping occurs when one object or shape in an image passes in front of another, interrupting its CONTOUR. Overlapping is one of the most basic means of creating an illusion of space and defining spatial relationships. It is most effective when the contour of the overlapped shape is broken aggressively. If the contours align, we may perceive the objects as adjacent to one another rather than in front or behind. Gaylen Hansen (Figure 116) consciously "violates" the conventions of overlapping in his painting.

The primary spatial device in William Conger's

FIGURE 93 Overlapping.

FIGURE 94 William Conger, *Aurea*, 1980, oil on linen, 48″ × 46″. Courtesy Roy Boyd Gallery, Chicago.

painting (Figures 94) is overlapping. Overlapping also invigorates the design of this poster (Figure 95). See also *shared contour.*

painterly suggestive of the free, fluid qualities and pronounced brushwork unique to PAINTING MEDIA. Painterly works reveal the artist's sense of touch and evoke the physical PROCESS of painting. The visual TEXTURE of the image often contributes to the painterly quality of a work. Painterly images generally are composed of broad strokes rather than tight linear activity.

FIGURE 95 Carl C. Regehr, 1982 Faculty Exhibition Poster, University of Illinois, silkscreen, 35″ × 23″. Collection of Krannert Art Museum, University of Illinois, Urbana-Champaign.

painting the process and result of creating images from a material composed of PIGMENT mixed with and suspended in a relatively fluid MEDIUM such as oil, acrylic resin, glue, egg yolk, melted wax, or water.

Paintings generally are defined by the interaction of broad areas of color rather than lines. Because of this, images created with PASTELS are often referred to as "pastel paintings."

palette (1) any range or combination of COLORS.

(2) a surface such as a flat board upon which small quantities of paints are placed and mixed. Typically, palettes for EASEL PAINTING are oval or oblong and many include a hole near the edge at one end where a thumb may be inserted. WATERCOLOR palettes have small indentations to hold pure and mixed colors.

paper a flexible material in sheet form made from matted and intertwined fibers. Paper generally is made from plant materials and is held together by the interlocking of the individual fibers rather than by an adhesive bonding agent. Papers may be treated with a chemical sizing agent to provide them with additional stiffness and stability. In addition, they may be subjected to pressure or run through rollers to control their surface TEXTURE. The working qualities of a paper are determined by the fiber of which it is composed and the manner in which it is formed.

When using water-based media on paper, care must be taken to avoid warpage resulting from the absorption of water into the fibers. The warpage is

not a problem when using oil-based MEDIA on paper. See also *cold press* and *hot press*

parallel perspective see *one-point perspective*

pastel (1) powdered PIGMENTS blended with a BINDER and CHALK and pressed into stick form. The hardness of pastels is controlled by the amount of binder used. Chalk is added to the pigment to control the depth of the color. Images created with pastels straddle the line between DRAWING and PAINTING. They can combine the dry and linear character of drawing with the blending of broad areas of color associated with painting.

(2) pale colors, such as pink or powder blue are TINTS of HUES at high VALUE or INTENSITY and often are referred to as pastel shades.

paste-up see *artwork*

Pattern and Decorative Painting a direction beginning in the mid-1970s toward highly active, DECORATIVE paintings employing an eclectic combination of colorful designs and MOTIFS. Many of the Pattern and Decorative painters emphasize emblematic patterns, brilliant COLORS, and fanciful combinations of surface TEXTURE, often incorporating textiles with colors and designs (sometimes FIGURATIVE) that interact discordantly.

Though certainly not all Pattern and Decorative painters have asserted social concerns as necessarily formative to their art, a number of the artists associated with the beginnings of the movement at the University of California at San Diego stressed both multicultural awareness and feminist issues as central to their work.

Among the major Pattern and Decorative Painters are Miriam Schapiro, Kim MacConnel (Figure 96), Valerie Jaudon, Robert Kushner, and Robert Zakanitch.

perceived color the sensed COLOR of an object. Perceived color is a result of the interaction of the eye and mind with the LOCAL COLOR of an object, light reflected from that object, and any intervening medium that filters or modifies that reflected light. For example, a white house seen at sunset or through a red filter might appear to be red or pink. While its local color is white, its perceived color is altered by the situation.

Our response to perceived color is relative to context. Although sunglasses shift the HUES of anything seen through them, the mind rapidly adjusts, and by interpolation we are still able to distinguish local color with a high degree of precision. See also *film color*; *volume color*

performance art action that combines aspects of the visual arts with components typically associated with theater and/or music. The action may be scripted, loosely or in a fairly prescriptive manner, or the movements or sounds may be completely impromptu. Artists may perform in COLLABORATION, and audience participation is sometimes an intended component of the work.

DADA, FUTURISM, and SURREALISM helped to fuel early forms of performance art. CONCEPTUAL ART has influenced much contemporary performance art.

permanence stability and unchangeability. Permanence has long been an issue in the arts. The devel-

FIGURE 96 Kim MacConnell, *Shakey*, ca. 1980-1981, acrylic on cotton, 92″ × 116″. Courtesy of the Holly Solomon Gallery, New York. Photo by D. James Dee, New York.

opment of PAINTING MEDIA has been driven by a search for PIGMENTS and BINDERS that would remain stable over time, without discoloration or separation from one another or from the SUPPORT.

In the twentieth century, permanence emerged as a philosophical issue as well. The DADA movement gave birth to art that was intentionally temporary. Many artists of the 1950s and 1960s disregarded

issues of permanence relating to the materials they employed. Their concerns were with PROCESS and conceptual issues, not the permanence of the art object. Artists including Barry Le Va and Robert Morris experimented with unconventional and previously untried media and methods without directing attention to the stability of their materials. With the passage of time, difficult problems of conserving such pieces have emerged for museums and collectors. Contemporary artists are increasingly aware of permanence as an issue in their work.

perspective literally "point of view." In art, perspective refers to some of the devices used to achieve an illusion of space in two-dimensional images. LINEAR PERSPECTIVE refers to DRAWING systems that represent the perceived diminution in size of objects as they recede into space, while ATMOSPHERIC PERSPECTIVE refers to the perceived effects of atmosphere on COLOR and VALUE.

photocomposition phototypesetting. The term refers to any of a number of systems that use photography to produce DISPLAY TYPE and/or the body of a text on photographic film or paper.

photomontage the combination of a variety of photographic images through pasting and/or superimposition to create new juxtapositions between the elements. Photomontage was a favored technique of the DADA era.

Photorealism a primarily American art movement of the late 1960s and the 1970s, sometimes referred to as Superrealism. Photorealism was based on the camera's rendering of the appearance of the external world and was attentive to the decision-making process involved in the translation of photographed imagery to PAINTING. While artists have used photography as a resource since the time of its invention, the Photorealists were the first to openly and aggressively copy photographic images. Many of the artists painted from slides projected directly onto their CANVASES and followed the photographic source religiously, mimicking the distortions of color and form inherent in photography.

Although the Photorealists were objective in the rendering of their images, often suspending aesthetic judgments during the actual process of painting, they made initial decisions in the choice of IMAGERY, FORMAT, and method of representation, which distinguished their work from simple copying.

The subject matter of most Photorealist paintings is mundane, from Chuck Close's greatly enlarged close-ups of ordinary faces to Richard Estes's urban environments (Figure 97). In this, the art of the Photorealists has been linked to POP ART, with its emphasis on easily accessible images drawn from everyday life.

The FLAT, impersonal surfaces of Photorealist paintings create impact through TROMPE L'OEIL effects, which evoke an awareness of the precision and care required in their making. In looking at a Photorealist painting, we are impressed as much by the artisanship as by the image.

The explicit detailing of the paintings provides a profusion of focused detail that corresponds much

FIGURE 97 Richard Estes, *Diner*, 1971, oil on canvas, 40$\frac{1}{8}$″ × 50″. Hirshhorn Museum and Sculpture Garden, Smithsonian Institution, Museum Purchase, 1977. Photographer, Lee Stalsworth. © Richard Estes/Licensed by VAGA, New York, NY/Marlborough Gallery, NY.

more to the way in which we see photographs than to the way we are inclined to see the world around us. Just as the camera makes no distinction between what is important or insignificant in recording a scene, so the Photorealists pay equal attention to all parts of their images, creating a visual field in which all parts of the picture compete for our attention. For example, Estes's attention to the complex reflections of the chrome surfaces of telephone booths gives the scene a complexity that we would likely disregard in normal viewing.

Other painters associated with the movement include Robert Bechtel, Audrey Flack, Ralph Goings, and Malcolm Morley.

pica a typographic measurement based on twelve POINTS, with ten characters per inch. Pica type frequently is used for typewriters and computer printers.

pictograph literally "picture writing." Pictographs are greatly simplified and stylized images that symbolize an action, concept, or procedure. Figure 98 was designed to indicate the location of a computer workstation within a public library.

pictorial space the illusionistic space represented within a picture. The pictorial space of an image is one of the strongest controllers of our response to that image. Artists manipulate pictorial space through a number of means including ATMOSPHERIC PERSPECTIVE, LINEAR PERSPECTIVE, OVERLAPPING, and SPATIAL COLOR.

The creation and control of pictorial space has emerged from time to time as a primary focus of artistic attention. In the Renaissance, artists explored linear perspective as a means of creating a unified pictorial space that conveyed a coherence and depth corresponding closely to human vision. In the nineteenth century, artists such as J. M. W. Turner created tangible pictorial space through the use of atmospheric perspective. In the mid-twentieth century, Hans Hofmann (Figure 107) and his followers concentrated their attention on the "PUSH AND PULL" effects of COLOR to create dynamic TENSIONS within a relatively shallow pictorial space. In the 1960s, artists such as Ellsworth Kelly (Figure 82) limited pictorial space by asserting the flatness of the PICTURE PLANE.

Ken Holder's painting (Figure 99) employs both atmospheric perspective and linear perspective, as well as overlapping and spatial color, in order to suggest the natural appearance of a Missouri River scene.

picture plane a sensed invisible plane coincident with the flat surface of a two-dimensional image. The sense of the picture plane frequently works in contrast to our sense of PICTORIAL SPACE, creating a TENSION between the two-dimensional art and the three-dimensionality of illusionary space.

pigment the material that provides COLOR in MEDIA. Pigments are chemical materials ground into fine powders. They may be used directly in their dry form, but usually are mixed with a BINDER to create a material with more controllable working characteristics.

Paints often are named after the pigment from which they are made. Cadmium red and cobalt blue are made from the minerals cadmium and cobalt. EARTH COLORS are so named because their pigments

FIGURE 98
A pictograph.

FIGURE 99 Ken Holder, *The Bridge at Hermann, Missouri,* 1999, acrylic on canvas, 32″ × 48″. Courtesy of the artist.

are clays. Burnt sienna and raw sienna originally were made from clay dug in the vicinity of Sienna, Italy, with the earth being used in its charred or "burnt" state in one, and in its "raw" state in the other.

Modern paints generally list the pigments on the label.

pixel the smallest bit of an image that may be shown on a digital display such as a computer monitor or video screen.

planographic those PRINTMAKING techniques that do not rely on RELIEF, the TEXTURE of the printing plate, to distinguish inked from non-inked areas.

Planographic techniques include LITHOGRAPHY, MONOTYPE, and SILKSCREEN.

point a unit of type measurement. There are seventy-two points per inch.

Pointillism term used to describe POST-IMPRESSIONIST PAINTINGS by Georges Seurat (Figure 87) and his followers. Pointillism describes the technique of intermingling small dabs or dots of relatively high-INTENSITY COLORS in order to achieve an optical mixture as a result of the BEZOLD EFFECT. This optical mixture is most effective if the viewer is at a distance from the CANVAS sufficient to allow the individual bits of color to blur and blend. This technique was the result of Seurat's interest in the work of the color theorists of his time. He called the technique and its resultant effect of bright, clean, pure color Divisionism.

polychromatic multicolored.

polymer medium ACRYLIC or ALKYD polymer used as a MEDIUM for acrylic paints. Polymer medium, available in glossy or matte form and as a liquid or gel, is used with acrylic or alkyd paints in much the same way the linseed oil (a natural polymer) is used with oil paints.

polyptych used to describe images composed of multiple frames or subformats within a single FORMAT. Polyptychs may be composed of physically discrete panels or a single SUPPORT with clearly defined BORDERS between several parts. Roger Brown's PAINTING (Figure 13) is a polyptych with six divisions. See also *diptych*, *multiple format*, *triptych*.

Pop Art originally used in the 1950s to describe the work of English artists including Peter Blake and Richard Hamilton who were exploring popular culture as a source for their imagery. Pop Art as an American art MOVEMENT originated in New York City in the early 1960s. Those artists most closely associated with Pop include Andy Warhol (Figure 100), Claes Oldenburg, Roy Lichtenstein, and James Rosenquist.

These Pop artists embraced images from the mass media and adopted techniques from the world of commercial art, including the bold graphics of billboard ILLUSTRATION and the FLAT, impersonal line of comic strips. Their forays into popular culture resulted in images that were familiar and accessible to the general public. Pop Art is characterized by a sense of humor and even irony in its elevation of mundane objects to the status of high art. One way this is accomplished is by enlarging commonplace objects and images and objectively rendering them in the medium of fine art, paint on CANVAS. Pop Art's origins lie in the nihilistic works of DADA, which had earlier challenged the boundaries between high art and the visual environment of the everyday world. The cool and emotionally uninvolved handling of the paint in Pop canvases was seen as a reaction against the emotional drama of the ABSTRACT EXPRESSIONIST works of the previous decade.

The New York–based Pop movement sparked an interest in the images of consumer culture among artists throughout the country, and distinctive variants of Pop Art developed in Chicago and on the West Coast.

positive shape shape also seen as FIGURE or foreground. Positive shape refers to those shapes actively produced by the artist. It is contrasted with NEGATIVE SHAPE. See also *figure/ground*

FIGURE 100 Andy Warhol, *Marilyn*, 1967, silkscreen, 36″ × 36″. Collection of Krannert Art Museum, University of Illinois, Urbana-Champaign.

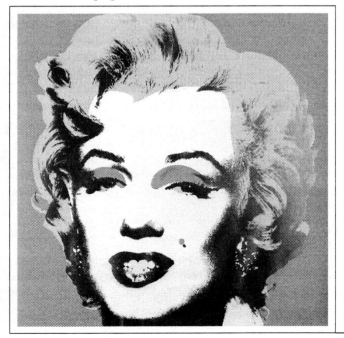

poster paint an inexpensive, opaque, water-based paint with a glue or gum BINDER.

Post-Impressionism a term coined in 1910 to describe the stylistic tendencies of those artists who pursued unexplored implications of the IMPRESSIONIST movement. Paul Gauguin and Vincent Van Gogh employed the heightened COLOR of the Impressionists to evoke intense psychological responses. Paul Cézanne (Figure 101), after exhibiting with the Impressionists, developed a more systematic style of brushwork and more rigidly structured compositions. Georges Seurat (Figure 87) and his followers are also commonly grouped with the Post-Impressionists. See also *Neo-Impressionism*

Postmodernism first widely used in the late 1970s to describe contemporary developments in architecture, Postmodernism now refers to tendencies including the layering and discontinuity of meaning in contemporary art and GRAPHIC DESIGN. It is characterized by freewheeling references to source materials of the past and the questioning of the possibility of originality in contemporary art.

Cindy Sherman's photographs, her self-portraits in a variety of guises, are typical of Postmodernist

FIGURE 101 Paul Cézanne, *Pines and Rocks: (Fountainebleau?)*, 1896-99, oil on canvas, 32″ × 25³/₄″ (81.3 cm × 65.4 cm). The Museum of Modern Art, New York. Lillie P. Bliss Collection. Photograph © 1999 The Museum of Modern Art, New York.

concerns. In images such as Figure 102 the artist has posed and costumed herself in such a way as to suggest that she is an actor in a NARRATIVE. Drama is implied, but the photograph points to no clear sequence of events.

Sherman's methods and procedures in making her images are highly deliberate. While costuming, stance, camera angle, and lighting are carefully planned, the finished work remains psychologically ambiguous. Visual information, even a surplus of information, is provided, but the pictorial and emotional clues do not constitute an expressive whole. This photograph is typical of the way in which Sherman stages each scene in such a way as to deny a complete and total understanding. The compelling reality of the photographic image contrasts with the psychological disorientation provoked by the missing links in the implied narrative. Alternate meanings collide, confuse, and subvert one another.

The APPROPRIATION of IMAGERY is a distinguishing characteristic of Postmodernism. Sherrie Levine's direct appropriation of historic comic strip imagery (Figure 17) raises questions about originality. The meaning of David Salle's *Footmen* (Figure 103) is clouded by the appropriation of a grinning face from a painting by the seventeenth-century painter Diego Velazquez and its juxtaposition with seemingly

FIGURE 102 Cindy Sherman, American, *Untitled (#103)*. 1982, type C print (8 of 10), on verso, in blue ink, © Cindy Sherman 8/10/1982, 30″ × 19³/₄″, 76.2 cm × 50.2 cm. Funds Given by the Contemporary Art Society. 800:1983, The St. Louis Art Museum (Prints, Drawing, and Photographs).

FIGURE 103 David Salle, *Footmen,* 1986, oil, wood bowl on canvas, 93″ × 120″, two panels. Collection of Jerry and Emily Spiegal. © David Salle/Licensed by VAGA, New York, NY.

unrelated images. Salle makes frequent use of imagery culled from the realm of high art as well as from popular culture—cartoon images, for example. With Levine and Salle, appropriation becomes an issue in and of itself, an issue that contributes to but does not explain the full meaning of the resultant image.

Postmodernism has been described as heralding the end of the modernist notion of an AVANT-GARDE. The experiment and risk that characterized MODERN ART movements and distinguished individual avant-garde artists such as Marcel Duchamp and Pablo Picasso as champions of the "new" is subverted by the Postmodernists' return to and revision of styles of the past. Their willful and sometimes witty eclecticism signals a desire to deconstruct FORM from CONTENT.

Precisionism a movement of the late 1920s and 1930s in American painting and photography in which artists concentrated on manufactured environments, with images of machines and the industrial landscape in general being primary concerns. These sub-

jects were presented with crisp, hard-edged clarity. While some artists, including Stuart Davis and Charles Demuth, developed GEOMETRIC styles directly inspired by CUBISM, others, including Charles Sheeler (Figure 104), stressed more naturalistic aspects of the interplay of crisp form and pattern in their MOTIFS.

primary color a HUE that cannot be created at its highest INTENSITY by mixing other colors. The pri-

FIGURE 104 Charles Sheeler, *American Landscape*, 1930, oil on canvas, 24″ × 31″ (61 cm × 78.8 cm). The Museum of Modern Art, New York. Gift of Abby Aldrich Rockefeller. Photograph © 1999 The Museum of Modern Art, New York.

mary colors are the essential elements in building a PALETTE with which to mix other colors. Systems have been built with any number of primaries, but the most common are the following.

SUBTRACTIVE: red, yellow, and blue. These are the preschool primaries with which most of us had our first color experiences through TEMPERA paints and fingerpaints.

ADDITIVE: red, green, and blue. These are the hues used by a TV set or a computer monitor (RGB—Red, Green, Blue) to create full-color images. These are also the basic colors used in theatrical lighting.

PROCESS: cyan, magenta, and yellow. These are the transparent inks used in simple printing to create full-color images.

primitive art the art of nonurban, nonindustrialized peoples. The term is used frequently to describe the traditional native arts of Africa, Oceania, and the Americas. In CONTENT and STYLE, primitive art is expressive of group or societal concerns and is often an integral part of ritual and religious practice. The AESTHETIC concerns of primitive art exist within strictly defined, formal parameters, and the works are generally highly stylized.

The artists of so-called primitive societies are highly trained and work to ensure continuance of their cultures' visual traditions. These traditions were developed in many situations over hundreds of years before the cultural influx from Europe and the Western world in general.

While primitive art does share characteristics with FOLK ART, it should not be confused with NAIVE ART.

primitivism the use of PRIMITIVE art as a model for formal innovation, particularly the expressive DISTORTION of FORM. The admiration of primitive art and the reference to its stylizations is consistent with the tendency of modern artists to look outside the established traditions of the fine arts in Western culture for sources rich in decorative or expressive potential.

printmaking reproductive image-making techniques. Printmaking MEDIA often are divided into three categories: INTAGLIO, PLANOGRAPHIC, and RELIEF. Printmaking is distinguished from other approaches to art-making by the act of transferring images from a plate or stencil to their final surface or SUPPORT. Printmaking media lend themselves to multiple reproductions of single images, but prints may also be unique, one-of-a-kind images.

process the act of producing. Throughout the course of MODERN ART, the process of making has been emphasized as a time of continuous decision making and deliberation. Interaction with the MEDIA as the piece is being made permits new possibilities and actions that will directly affect the appearance of the finished work. Rather than allowing the process of making to be limited to the straightforward ILLUSTRATION of a preconceived idea, an emphasis on process fosters spontaneity and "controlled accident," allowing the inherent properties of the medium, such as the fluidity of WATERCOLOR, or the softness of PASTEL, to offer new FORMAL possibilities.

Vera Klement's concern with process makes her PAINTINGS documents of their formal evolution, of their coming into being. Beginning with a series of THUMBNAIL SKETCHES (Figure 105), Klement develops the image. Moving to CANVAS, she allows her interaction with the medium, a malleable ENCAUSTIC, to guide the development of the paint-

ing (Figure 106), bringing diverse elements into an AESTHETIC balance.

process color inks and paints used in commercial printing. Process COLOR refers to the transparent colors cyan, magenta, and yellow, often overprinted with black in much color printing and SILKSCREEN. In this form of printing, a full-color image is photographically separated into discrete images that are printed one on top of the other, yielding the finished work. Much ARTWORK today is processed through high-resolution drum scanners into HALFTONE dots for reproduction by process color. See *primary color*; *spot color*.

proportion the relationship in scale between one element and another, or between a whole and one of its parts. Proportion refers not to absolute size or amount, but to a comparison of dimensions. In OBJECTIVE DRAWING emphasis is placed on establishing correct proportional relationships between the parts of objects and between the objects represented. When transferring a scene to two dimensions, an artist may hold a pencil up in front of the scene as a simple tool to measure relative size and angles within that scene.

Intentional violation of actual proportional relationships often is employed for expressive reasons. Alice Neel's portraits (Figure 7) are noted for their

FIGURE 106 Vera Klement, *Between Door and Distance*, 1987, oil and wax on canvas, 6′ × 9′. Courtesy of the artist.

vitality and are distinctive in the way their proportional relationships are altered.

push and pull a phrase used to characterize color interactions within the paintings of Hans Hofmann, one of the most influential painters and teachers of ABSTRACT EXPRESSIONISM. Specifically, "push and pull" describes the spatial interaction of COLOR and the sensation of colors expanding and contracting, advancing and receding, providing a dynamic TENSION not only upon the PICTURE PLANE, but immediately in front of and behind it as well (Figure 107).

quadratic harmony a COLOR HARMONY based on the interrelationship of four HUES equidistant from one another on the circumference of the COLOR WHEEL. Quadratic harmonies can be found by inscribing a square over the color wheel.

FIGURE 107 Hans Hofmann, American, born Germany 1880-1996. *The Golden Wall*, oil on canvas, 1961, 151 cm × 182 cm. Mr. and Mrs. Frank G. Logan Prize Fund, Photograph © 1999, The Art Institute of Chicago. All Rights Reserved.

radial symmetry SYMMETRY around a point. Images with radial symmetry have a strong central FOCAL POINT. BILATERAL SYMMETRY exists across any AXIS drawn through the FOCAL POINT.

Realism a movement originating in France during the mid-nineteenth century that stressed subject matter representative of its own particular time. Realist artists struggled against academic conventions to present an objective view of their daily lives. Scenes of commonplace activities were offered without the idealization or sentimentalism characteristic of mainstream art of the time.

The rallying cry of the movement, "to be true to one's own time," led artists to a new range of subject matter. Believing that art should be based only on what could be experienced in the course of everyday life, the Realists rejected literature, history, and religious subject matter as a basis for their paintings. This resulted in IMAGERY as diverse as Gustave Courbet's shabby peasant workers and Edouard Manet's fashionable young Parisians. The Realist insistence on a direct representation of the visible world served as a foundation for the IMPRESSION-ISTS, who went beyond Realism in a concerted effort to depict not only what was seen, but also the instantaneous sense of that vision.

The Gross Clinic (Figure 108) by the American painter Thomas Eakins was originally rejected from an exhibition because the subject matter, an operation in progress, was considered repellent in its straightforward rendering of blood and open flesh. The audience of the time failed to respond to the

FIGURE 108 Thomas Eakins, *The Gross Clinic*, 1875, oil on canvas, 96″ × 78″. From the Jefferson Medical College of Thomas Jefferson University, Philadelphia.

more important aspect of the painting, the calm and deliberate demeanor of Dr. Gross as he explains the procedure.

A major goal of some Realists was to celebrate the worthiness of real people. They believed that the artist can alert us to the dignity evident even in the most humble aspects of daily life. These considerations are evident in works by such contemporary artists as Karl Moehl (Figure 109), who, in an informal portrait of a college student, suggests an optimism and determination characteristic of youth.

Regionalism an art movement of the 1930s that focused on rural scenes and subjects as a means of extolling the cultural attitudes and values of "ordinary" Americans, particularly Midwesterners. Regionalist artists including Thomas Hart Benton, John Steuart Curry, and Grant Wood (Figure 27) worked with REPRESENTATIONAL IMAGERY and shunned the ABSTRACT stylistic developments which were a part of MODERN ART in Europe at that time.

relief PRINTMAKING techniques in which the parts of the image not to be printed are carved or etched away from the plate, leaving the raised to be printed. Common relief printmaking techniques include linoleum block prints, WOODCUT, and WOOD ENGRAVING.

repetition multiple occurrence. Repetition is a fundamental unifying factor in many works of art. Any of the FORMAL ELEMENTS may be repeated in an image.

FIGURE 109 Karl Moehl, *Mike IX, (Adventurer),* 1978, acrylic on canvas, 42″ × 30″. Courtesy of the artist.

Repetition may be obvious, with clearly discernible patterns such as those found in the work of Roger Brown (Figure 13), or it may be more subtle, as in the work of Hans Hofmann (Figure 107), which uses repetition of similar shapes, TEXTURES, and COLORS.

representational having the qualities of resemblance. Representational art is made up of imagery that is intended to bear a visual resemblance, however ABSTRACT, to the external world. Representational art may be highly abstract, as in de Kooning's *Woman II* (Figure 8), fragmented between abstract passages and images with varying degrees of correspondence to objects and figures of the real world, as in Sigmar Polke's painting (Figure 110), or presented with the NATURALISM characteristic of April Gornik's *Storm and Fires* (Figure 111).

Representational art poses an opposite approach to NONOBJECTIVE art.

resist in ETCHING, a material impervious to acid. Resist is used to protect areas of the plate from being etched. Common resists include asphaltum, beeswax, and rosin.

rhythm regular repetition. In art, rhythm results from the perception of intervals between repeated elements or gestures in an image. Rhythms may be described as regular, flowing, progressive, syncopated, or a combination of the above.

sans serif TYPE without SERIF.

saturation see *intensity*

scale the relative, perceived, or experienced size of an image or object.

scanning the electronic translation of an image or text document into digital data. A scanning device uses a grid system to break the image or text into component parts which then are reassembled in the computer for viewing on a display screen. Images that have been scanned may be stored on digital media, edited and manipulated with graphics software, and transferred over a network or over the Internet.

school in art, a school refers to a group of artists whose work springs from a common body of thought and

FIGURE 110
Sigmar Polke, *Untitled,* 1968, watercolor, acrylic spray, and gouache on paper, 37¼″ × 25″ (95.9 cm × 63.6). The Museum of Modern Art, New York. Gift of R.L.B. Tobin. Photograph © 1999 The Museum of Modern Art, New York.

shares certain characteristics of STYLE and/or CONTENT. For example, the 1950s New York School was bound together by shared concepts of the importance of FORMAL concerns in art making and by the expression of those concepts. See also *movement*

script hand-written text. The use of script as opposed to TYPE to present TEXT conveys a sense of the presence of the artist and of the uniqueness of the object. In *Lady Liberty of 1953 to 1962?* (Figure 112), an informal, almost conversational quality is evoked by

FIGURE 111 April Gornik, *Storm and Fires*, 1990, charcoal and pastel on paper, 47⅛″ × 38¼″. National Museum of American Art, Washington, D.C./Art Resource, N.Y.

FIGURE 112 Peter A. Besharo (1899-1960), *Lady Liberty of 1953 to 1962?*, house paint and metallic paint, varnish and pencil on paperboard, ca. 1962, 22⅝″ × 28½″. National Museum of American Art, Washington, D.C./Art Resource, N.Y.

the handwritten caption. The intimacy conveyed by the artist's handwriting provides a window into his life and mind.

As this World War II poster indicates, a TYPEFACE

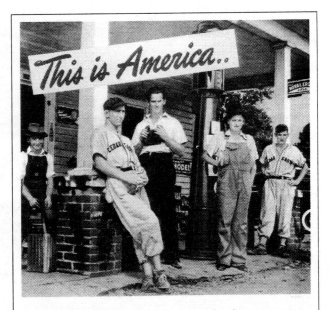

FIGURE 113 Dorthea Lange, *Where a Fellow Can Start on the Home Team and Wind Up in the Big League*, from the series "This Is America," 1942. Photomechanical lithograph, 36″ × 24″ (91.4 cm × 61 cm). The National Museum of Modern American History, Smithsonian Institution. Gift of the Sheldon-Claire Company.

which approximates the appearance of script can interject an added immediacy to an image (Figure 113).

secondary color a HUE that results from mixing two PRIMARIES. Secondary colors are found midway between the primaries on the circumference of the COLOR WHEEL (Figure 114).

semiotics the study of signs and SYMBOLS. Semiotics has its roots in philosophy—specifically in linguistics, the study of the origin and the location of meaning within language. The Swiss linguist Ferdinand de Saussure, writing in the late nineteenth and early twentieth centuries, argued that language is constructed as a phenomenon of human interaction,

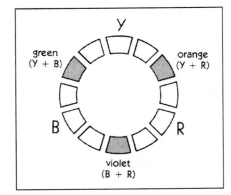

FIGURE 114 Secondary colors.

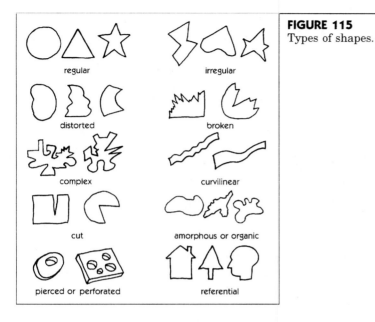

FIGURE 115
Types of shapes.

regular · irregular

distorted · broken

complex · curvilinear

cut · amorphous or organic

pierced or perforated · referential

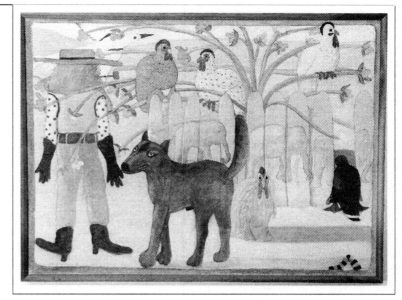

FIGURE 116 Gaylen Hansen, *Kernel in the Farmyard*, 1974, acrylic on canvas, 36½″ × 49″. Private collection.

and as such it is subject to constant change and evolution. The implications of his teachings for the visual arts stress that any art creation may be regarded as a sign. The two components of the sign are its physical existence as a signifier, and its meanings or possible interpretations, the signified.

serif a small terminating line at the bottom and/or top of a letter.

serigraphy see *silkscreen*

shade a COLOR of a lower VALUE made by mixing the color with black. See also *tone*

shape a closed CONTOUR. Shape is understood in terms of its perimeter or outline. Shapes are characterized in a variety of ways and derive their character from the interrelationships of the parts of their contours (Figure 115).

shared contour an intentional violation of the conventions of OVERLAPPING. Shared contour is achieved by placing spatially separated objects in such a way that their contours align visually. This suggests that they are adjacent to one another, an effect that flattens and distorts the PICTORIAL SPACE.

Gaylen Hansen (Figure 116) makes active use of shared contour to create multiple ambiguities in his

work. Note for example how the tail of the dog fits into the row of fence posts.

silkscreen a PRINTMAKING PROCESS in which colored inks are forced through a fine fabric mesh. The areas to be printed are controlled by blocking out the sections of the mesh that are not intended to print. Silkscreen lends itself to the reproduction of broad, flat areas of COLOR.

silverpoint a DRAWING technique in which marks are made by rubbing a soft, nonferrous metal, usually silver, on a GESSO or similar GROUND. With silverpoint, the metal is the PIGMENT, and it is deposited directly on the ground with no MEDIUM. The mark-making process is comparable to dragging a coin on a painted wall.

Silverpoint produces a delicate, semitransparent mark that changes in time as the metal oxidizes. As a silverpoint drawing "matures," the LINE assumes the richness and range of COLOR of tarnished silver.

While silver is the metal most often used, silverpoint can be done with any relatively soft metal that can be abraded by the ground.

simultaneous contrast a phenomenon of PERCEIVED COLOR. When a relatively small area of one COLOR is presented against a field of another color, our perception of the smaller area of color is altered in response to the relationship between the two colors.

Simultaneous contrast effects first were discussed at the end of the nineteenth century by the French color theorist Michel Chevreul, a chemist specializing in dyes for textiles. He noticed that the perceived color of the threads in tapestries changed depending on the colors of the surrounding areas of the fabric.

The mind may be understood as a kind of image-enhancement device. It focuses its attention on the figure in FIGURE/GROUND relationships. To aid in this focusing of attention, the mind enhances the contrasts between figure and ground by seeking out differences and exaggerating them. For example, when viewing a gray dot against a black or white background (Figure 117), the mind seizes on the contrast in VALUE and magnifies it. Against the low-value background, the gray is perceived as higher in value (lighter) than when it is seen against the high-value background.

In order to enhance contrast, the mind seizes on whatever contrast is available between two visual events. Just as a neutral grey will be perceived as higher or lower in value depending on its context, HUE and INTENSITY also are tempered by context. When two colors interact, the mind seeks to increase the contrast between them. It is for this reason that COMPLEMENTARY hues seem to "vibrate" when juxtaposed. The COLOR WHEEL shows that the two hues are already as far apart as possible and that it is not possible to increase the contrast between them.

FIGURE 117
Example of simultaneous contrast of value.

The importance of simultaneous contrast to the artist is that color decisions cannot be made independent of context. Specific decisions, especially regarding value, must be made by viewing proposed color in its intended surroundings.

sketch a DRAWING made in support of a finished work. Sketches are preparatory drawings. They may be made before work is begun on a piece or while it is in process. The purpose of a sketch may be to record a new idea, to explore possible compositions, to resolve difficulties with one or another of the details of an image, or simply to provide an outlet for visual ramblings and musings.

Sketches are often incomplete. They also may be accompanied by written notes. Sketches convey a sense of possibility revealed, of thought in action. They may be distinguished from finished works by their apparent casualness.

While we generally associate art and design with finished products, it is important to realize the essential role that sketches play in the design process. Failings in finished works often can be attributed to a failure to sketch adequately, rather than to a lack of ability on the part of the artist or designer.

sketchbook a bound book of blank paper used for the development of ideas, the recording of thoughts, the taking of notes, doodling, and drawing. This page from Chris Starkey's sketchbook (Figure 118) provides a tangible and visible record of the mental process. Its primary importance is as a chronicle of the evolution of the artist's thinking.

FIGURE 118 Christopher Starkey, sketchbook page (untitled), 1997, graphite on paper. Courtesy of the artist.

A sketchbook can be useful to the artist long after it is completed. Retrospective examination of where one has been can yield insight into where one is and where one's work may be leading. It is striking how often the major themes of an artist's mature career can be discerned in early sketchbooks.

There is nothing inappropriate for inclusion in a sketchbook. As a visual journal, the sketchbook is in many ways the most important artifact created by the student or mature artist.

Social Realism a human-centered art that addresses the political and social situations of its time. Social Realism is directed to a mass audience. Its messages and concerns are not elitist. The stylistic tendencies of Social Realist painters are characterized by a generalized realism and a rejection of ABSTRACT tendencies in so far as they detract from the legibility of the IMAGERY and its message.

In North America, Social Realism traditionally has been associated with the political left. Its history is primarily identified with the Mexican mural movement and art produced for the Works Progress Administration of the depression era. It has centered on problems affecting workers, the poor, and the socially disadvantaged. Artists associated with Social Realism included Ben Shahn and the muralist Diego Rivera.

In totalitarian states such as the Soviet Union, Social Realism became the official government style. Rather than being an expression of conflict or protest, Social Realism was used in this context as a vehicle to assert common goals and accomplishments. Natalya Pench's poster *Fulfilling the Pro-*

FIGURE 119 Natalya Pench, *Fulfilling the Program for Cast Iron, Steel and Wrought Metals is the Task of the Workers of the Entire Nation*, 1932, lithograph, 54″ × 39″. Collection of Krannert Art Museum, University of Illinois, Urbana-Champaign.

gram (Figure 119) praises the heroism of industrial employees who through their work serve their country.

spatial color the use of color to enhance an illusion of space or depth. It commonly is thought that color has spatial qualities. WARM, opaque, and high-INTENSITY colors are seen as advancing toward the viewer, while COOL, transparent, and low-intensity colors are seen as receding into the PICTURE PLANE. See also *push and pull*

split-complementary harmony a COLOR relationship in which a dominant HUE is balanced by colors found on both sides of its true COMPLEMENT on the circumference of the COLOR WHEEL. For example, a split-complementary harmony could be built around a yellow by balancing it with blue-purple and red-purple (Figure 120).

spot color a term with particular application to GRAPHIC DESIGN, spot color refers to ink color that is mixed before printing, just as paint is mixed, to create a specific color. For example, if orange is the desired color, it will be made by mixing yellow and red inks, providing the appropriate result for printing.

Spot colors can be specified using a COLOR MATCHING SYSTEM (see process color).

stencil a thin sheet of material from which an image to be produced is cut. The negative (open) area of the stencil usually, but not always, translates as POSITIVE SHAPE in the created picture.

The stencil process can be used to encourage an impersonal look in the making of pictures. Additionally, stencils are a means of allowing artists to readily reproduce an image or set of images across a BODY OF WORK.

complement of Y = v
split complement of Y = Bv + Rv

Hue	Complement	Split-complement
YELLOW	violet	RED-violet BLUE-violet
orange	BLUE	BLUE-violet BLUE-green
RED	green	BLUE-green YELLOW-green
violet	YELLOW	YELLOW-green YELLOW-orange
BLUE	orange	YELLOW-orange RED-orange
green	RED	RED-orange RED-violet

FIGURE 120 Split-complementary harmonies.

Stencils often are used with AIRBRUSH and in SILKSCREEN.

(de) Stijl a Dutch art MOVEMENT founded in 1917 that expanded CUBIST concerns for geometry and measured space. De Stijl painters, including Piet Mondrian (Figure 121) and Theo van Doesburg, began working with NATURALISTIC imagery, but simplified their CANVASES to GEOMETRIC abstractions based on the dynamic interplay of asymmetrically placed rectilinear units of unmodulated PRIMARY COLORS. De Stijl

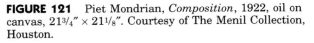

FIGURE 121 Piet Mondrian, *Composition*, 1922, oil on canvas, 21³/₄″ × 21¹/₈″. Courtesy of The Menil Collection, Houston.

artists envisioned widespread applications for their AESTHETIC, and sculptors, architects, and designers became active with the group. The movement collapsed with the advent of World War II, but its major concerns have had a continuing impact on the visual arts, especially graphic design and architecture.

still life an image based on a grouping of inanimate objects. A still life may be a purely FORMAL study, or it may make symbolic or ALLEGORICAL references. The degree of NATURALISM in still life can vary from a detailed rendering of observed reality (Figure 133) to bold abstraction.

study a SKETCH, DRAWING, or PAINTING made to explore details of FORM or COMPOSITION in preparation for a finished piece. Compositional studies, such as the architectural rendering by Ludwig Mies van der Rohe (Figure 122) or Vera Klement's THUMBNAIL SKETCH (Figure 105), omit the detail of the finished piece, while detail studies focus on specific elements of the finished piece. Studies can convey a sense of informality, freshness, and daring that may be lacking in a finished work, and they may provide insight into the artist's decision-making process.

style a distinctive manner of visual expression in which the FORMAL ELEMENTS of a work are combined in such a way as to give a consistent visual expression to the work.

The term style has a broad range of applications. Style can refer to the interaction of the artist's touch with his or her MEDIUM, as, for example, a PAINTERLY

FIGURE 122 Ludwig Mies van der Rohe, American, born Germany 1886-1969, Perspective sketch of the interior of a court house with mural, ink on paper, ca. 1931-38; 21 cm × 30.1 cm. The Art Institute of Chicago, Gift of A. James Speyer. 1981.934. Photograph © 1999, The Art Institute of Chicago, All Rights Reserved.

style. Personal style describes the singular look of a given individual's work. As an artist matures, he or she may embrace a personal style that becomes as unique as handwriting or a signature. Historical or period style refers to the distinctive look of works of art produced within a given period of time or historical context. Picasso's "Blue Period" is an example of period style—a definable episode within his career. Style also describes the appearance of works produced by a SCHOOL or by artists of a given region, for example, the style of French IMPRESSIONISM.

Style refers exclusively to the visual appearance of a work of art. A particular style or set of stylistic characteristics may typify a MOVEMENT, but style alone typically is not enough to define a movement.

subtractive color color created by the absorption of light frequencies by pigments or filters. Subtractive color describes the ways in which paints are mixed or what will be seen through stacked filters of various colors. When COMPLEMENTS are mixed subtractively, the result is a low-INTENSITY HUE tending toward dark gray. When they are mixed ADDITIVELY they tend toward white.

Superrealism see *Photorealism*

support the surface on which a two-dimensional image is made. Common supports include CANVAS, ILLUSTRATION BOARD, and PAPER.

Suprematism a Russian MOVEMENT of the late 1910s and 1920s based on a belief in the spiritual transcendence of NONOBJECTIVE forms divorced from the external world of material realities. The prime exponent of Suprematism, Kasimir Malevich, began working in a CUBIST-inspired mode but found the pictorial references to things of the natural world restrictive and incompatible with his mystical outlook. His mature works, as those by other Suprematists, are characterized by paintings based on the interplay of sharply defined rectilinear units of FLAT COLOR (Figure 123).

As with CONSTRUCTIVISM, Suprematism found a sympathetic audience at the BAUHAUS, where many artists were predisposed to a high degree of abstraction in painting.

surreal a strange hyper-real or "beyond the real" quality. Surreal imagery frequently conveys dreamlike traits through meticulously represented forms juxtaposed in bizarre and unexpected ways. Surreal also describes works that provoke ambiguous, disconcerting, and unsettling feelings.

FIGURE 123 Kasimir Malevich, *Suprematist Composition*, 1916, oil on canvas, 18″ × 13³/₄″. Courtesy of The Menil Collection, Houston.

The term "surreal" commonly is used to describe works created outside the art movement SURREAL-ISM. While there are strong correlations between contemporary works with surreal qualities such as those by Kenny Scharf (Figure 124) and the images produced by artists of the Surrealist movement, the contemporary artist working with surreal imagery does not necessarily subscribe to the goals of the Surrealists.

Surrealism a movement launched in Paris in 1924 by the poet André Breton, who declared his purpose to be a search for the higher reality—the "surreality"—of the subconscious mind. Greatly influenced by FREUDIAN theory, Breton viewed the subconscious mind as the repository of the imagination, and he urged artists to bring repressed irrationalities held in the subconscious to the surface in pictorial form. Surrealism aimed to liberate the artistic imagination from complacency and subservience to middle-class values.

Two separate but interdependent types of imagery emerged in the early years of the movement. Abstract (or Calligraphic) Surrealism is characterized by the interplay of highly ABSTRACT or NONOB-JECTIVE forms, frequently BIOMORPHIC in appearance, which often were generated by automatic techniques (see *automatism*) similar to those employed earlier by artists of the DADA movement. Among the artists of this branch of Surrealism are André Masson, whose works typically convey a sense of violence, and Joan Miro, whose PAINTINGS are generally fanciful and lyrical.

FIGURE 124 Kenny Scharf, untitled, 1998, lithograph, 30″ × 20″. Printed by Normal Editions Workshop, Illinois State University.

The veristic (or illusionistic) branch of Surrealism used strange juxtapositions of visually incongruous elements, usually rendered with a clear illusionism, so that the pairing of objects would evoke a hallucinatory sense of mystery or dread. Violence and repressed sexual yearnings frequently served as subjects for these artists, and their works had tremendous shock value for the established tastes of the time. The paintings of Salvador Dali and Rene Magritte exemplify this branch of Surrealism.

The enigmatic paintings of Max Ernst (Figure 125) and Yves Tanguy incorporate aspects of both branches of Surrealism and are indicative of the visual interplay between the two directions.

As a movement, Surrealism was largely played out by the onset of World War II, though its influ-

FIGURE 125 Max Ernst, *Surrealism and Painting*, 1942, oil on canvas, 77″ × 92″. Courtesy of The Menil Collection, Houston.

ence persisted after the war as the ABSTRACT EXPRESSIONISTS continued investigations into the workings of the subconscious mind.

symbol an image that represents something other than itself. Symbols are understood in two ways: as images in their own right, and as surrogates for that which they represent.

In GRAPHIC DESIGN, symbols can be REPRESENTATIONAL or ABSTRACT. See also *semiotics, trademark*

Symbolism a late-nineteenth- and early-twentieth-century movement that stressed mysterious subjects and provoked complex and often unsettling emotions. Symbolism is regarded as a reaction against the NATURALISM of IMPRESSIONISM, and its emphasis on optical sensation and accessible subject matter. Symbolism reinstated romantic ties to literature and

often evoked imaginative NARRATIVE situations. Symbolist artists including Gustave Moreau and Odilon Redon (Figure 126) developed distinctly personal styles responsive to their eccentric and highly subjective concerns.

symmetry the correlation between images reflected about an AXIS. Common forms of symmetry include BILATERAL SYMMETRY and RADIAL SYMMETRY.

synaesthesia literally, the confusion or substitution of one sense for another. In art the term is used metaphorically, for example, to describe such effects as COLOR so vibrant that it "resounds." The concept held strong significance for the Russian painter Wasily Kandinsky, one of the first painters of NONOBJECTIVE works.

tension used to describe situations or structures that seem in flux or unresolved. Tension arises in situations where something is sensed as being "about to happen." It is important not to confuse tension with agitation or chaos. Tension is present in the quiet before the storm and is introduced in a structure before that structure is placed under stress. If the structure succumbs to the pressure, the tension is relieved.

In art and design, tension results from a dynamic opposition of FORMAL ELEMENTS suggesting unresolved relationships or events about to happen. Tension can be introduced through contrasts of COLOR (as in PUSH AND PULL), through FIGURE/GROUND ambiguities, or other dynamics of the COMPOSITION.

In Kasimir Malevich's *Suprematist Composition* (Figure 123) FORMAL tension is created between

FIGURE 126
Odilon Redon, *Silence,* (ca. 1911), oil and gesso on paper, 21¼″ × 21½″ (54 cm × 54.6 cm). The Museum of Modern Art, New York. Lillie P. Bliss Collection. Photograph © 1999 The Museum of Modern Art, New York.

"large" and "small" rectilinear areas and between the sole curved line opposed to the other straight lines.

Ron Jackson's painting creates tension through the juxtaposition of drawn lines as opposed to linear patterns occurring naturally on the wood support.

Psychological tension also can be brought into an image by creating unresolved NARRATIVE situations or through the introduction of surprising or unexpected elements.

tertiary color a HUE that is the result of mixing a SECONDARY COLOR with an adjacent PRIMARY; it is found between the two on the COLOR WHEEL (Figure 128).

Some color-mixing systems refer to HUES of moderate intensities (Figure 129) as tertiaries.

text words. When words become an active part of a work of visual art, our relationship to that art object is very different from when we are confronted with only FORMAL information. The introduction of text into an image activates a different kind of understanding on the part of the viewer. While we can stand before a PAINTING and passively allow the image to "wash over" us, an image with text in it requires action—reading.

The act of reading affects the understanding of works of art in a variety of ways. Reading is linear—words are read in order. The mind does not wander through a paragraph in the same way it can through a landscape. Additionally, reading generally implies an intermediate translation of letters to words and words to images, while a DRAWING or painting may be grasped nearly immediately. Finally, recent research regarding the workings of the brain suggests that reading, the interpretation of word, is an activity of the left hemisphere of the brain; the inter-

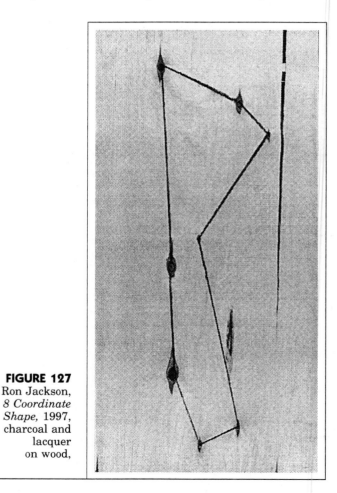

FIGURE 127
Ron Jackson, *8 Coordinate Shape*, 1997, charcoal and lacquer on wood,

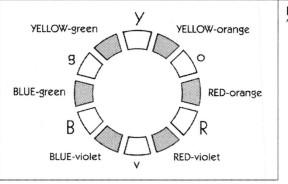

FIGURE 128
Tertiary hues.

pretation of spatial relationships, looking at images, is an activity of the brain's right hemisphere.

Since CUBISM, modern artists have explored the use of text in their works. Occasionally, words may function as SYMBOLS. At other times, words may appear as part of complex images, providing formal variety and adding an opportunity for a secondary level of revelation and meaning, as in the Rauschenberg print (Figure 130), where the words not only

FIGURE 129 Tertiary intensities.

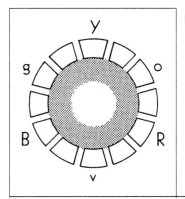

FIGURE 130 Robert Rauschenberg, *Sky Garden*, 1969, lithograph and silkscreen, 89″ × 37⅝″. Collection of Krannert Art Museum, University of Illinois, Urbana-Champaign.

label objects depicted but call attention to the process of designing the spacecraft.

Text becomes a dominant force when it is the primary vehicle for meaning in an image. This is the case in René Magritte's painting (Figure 131). This CANVAS, an image of a pipe, reads (in English) "This is not a pipe." Titled *The Treason of Images*, it speaks explicitly about issues of representation and interpretation. See also *script*; *semiotics*; *type*

texture tactile surface. In art and design, texture may be physical, as in IMPASTO, or it may be purely visual. Visual textures result from the creation of a field of marks small enough, close enough, and in sufficient quantity that we relate to them as a pattern, a visual whole. Visual texture may mimic external reality with TROMPE L'OEIL effects, or it may be more ABSTRACT.

Hollis Sigler's explicit brushwork endows her painting (Figure 132) with a strong physical as well as visual texture, creating a vigorous surface emphasis.

James Butler creates a range of purely visual textures in his STILL LIFE (Figure 133).

three-dimensional forms that extend into space and can be measured in terms of height, width, and depth.

FIGURE 131 René Magritte, *La Trahision des images (Ceci n'est pas une pipe)*1928-1929, oil on canvas, 27⁷/₁₆″ × 37¹/₁₆″. (64.50 cm × 94.00 cm). Los Angeles County Museum of Art. Purchased with funds provided by Mr. and Mrs. William Preston Harrison Collection. © 2000 C. Herscovici, Brussels / Artists' Rights Society (ARS), New York.

FIGURE 133 James Butler, *Still Life with Glass and Clay,* lithograph, 24″ × 34″. Courtesy of the artist. Printed by Normal Editions Workshop, Illinois State University.

FIGURE 132 Hollis Sigler, *She Has Secrets Even from Herself,* 1986, oil on board, 12″ × 12″. Elmhurst College Library. Photograph courtesy of the artist.

three-point perspective a form of LINEAR PERSPEC-
TIVE used to represent scenes from an exaggerated
point of view. In three-point perspective vertical
LINES as well as horizontal lines recede to VANISHING
POINTS (Figure 134). Three-point perspective is often
used to represent either a BIRD'S EYE VIEW or a
WORM'S EYE VIEW.

thumbnail sketch a very small SKETCH with little or no
detail. Thumbnail sketches aid in the visualization of
COMPOSITION and VALUE relationships (Figure 105).

tint a COLOR mixed with white. When a paint is mixed
with white, its VALUE is raised, creating a tint. This
mixed color generally will have a lower INTENSITY
than pure color.

tinting strength a measure of the extent to which a
paint maintains its INTENSITY when mixed with

FIGURE 134 Three-point perspective.

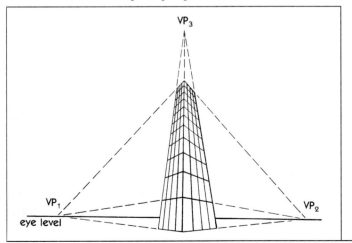

white, with higher strength attributed to those
paints that best maintain their intensity. Tinting
strength varies depending on the PIGMENT used in
the formulation of the paint.

tone a lower-INTENSITY COLOR made by mixing a HUE
with its COMPLEMENT. Tones usually are of lower
VALUE than the base hue and often are considered
richer than SHADES because of the use of the com-
plement.

Tones bridge the gap between complementary
hues, reducing the extremity of contrast and unify-
ing images built around a complementary harmony.

Some color-mixing systems consider mixtures of a
hue with black to be tones. Such a mixture yields
results similar to the mixture of a hue with its com-
plement, but at a lower value.

topical having CONTENT that refers to specific contem-
porary social or political events. Leon Golub (Figure
135) uses his art to make forceful statements about
political and human rights issues.

trademark a SYMBOL used for corporate identification
of a concept, product, or service.

transparent watercolor a water-thinned PAINTING
material that is applied in a transparent WASH over
a white PAPER GROUND. Transparent watercolor
relies on the white of the ground for high VALUES.

Watercolor may be handled in a variety of ways.
In Don Lake's industrial scene (Figure 136), the
MEDIUM is carefully built up in layers so that the
metallic surfaces of the machinery as well as clouds
of steam are clearly evoked through the smooth sen-

FIGURE 135 Leon Golub, American, born in Chicago in 1922, *Mercenaries II*. 1979, acrylic on canvas, height 305 cm, width 366 cm. Musée des Beaux-Arts de Montreal. Purchase, Horsley and Annie Townsend Bequest. Photo by Brian Merrett, MBAM/MMFA.

FIGURE 136 Donald Lake, *Industry, Vein*, 1993. Transparent watercolor, 16″ × 24¼″. Courtesy of the artist.

sation of flat COLOR. John Marin (Figure 137) used a more fluid and EXPRESSIONISTIC GESTURE, maintaining our awareness of the surface of the paper as a key element in the work.

triadic harmony a COLOR HARMONY based on the interrelationship of three HUES equidistant from one another on the circumference of the COLOR WHEEL. The PRIMARY COLORS form a triadic harmony as do the SECONDARY colors. Additional triadic harmonies can be found by inscribing an equilateral triangle over the color wheel (Figure 138).

triptych a work of art composed of three adjacent but independent panels or FORMATS, presented together and meant to be viewed as a single unit.

trompe l'oeil French for "trick the eye." Trompe l'oeil (pronounced "tromp-loy") PAINTING or DRAWING seeks to fool the viewer into believing that the rendered image is truly there rather than merely represented.

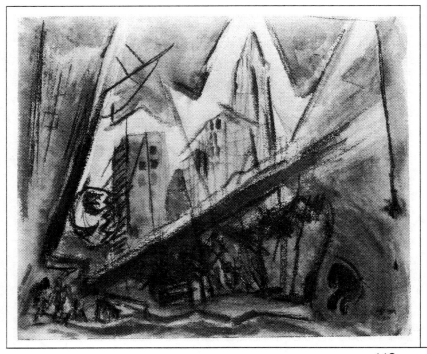

FIGURE 137 John Marin, *Lower Manhattan*, 1920, watercolor and charcoal on paper, $21^{7}/_{8}$″ × $26^{3}/_{4}$″ (55.4 cm × 68 cm). The Museum of Modern Art, New York. The Philip L. Goodwin Collection. Photograph © 1999 The Museum of Modern Art, New York.

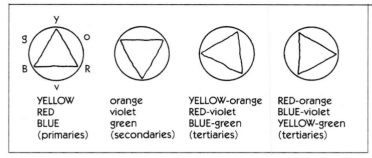

FIGURE 138 Triadic harmonies.

Most works of art require viewers to suspend disbelief and actively engage their imagination in order to complete the image and make it believable. Trompe l'oeil is more extreme than most REPRESENTATIONAL art in that it fools us, at least for a moment, into seeing things that are not there.

two-dimensional flat. Two-dimensional objects are described in terms of height and width. Their thickness is not considered significant except as TEXTURE.

two-point perspective a form of LINEAR PERSPECTIVE that is used to represent objects seen at an angle relative to the PICTURE PLANE. In two-point perspective only verticals remain parallel to the picture plane; all other lines recede to VANISHING POINTS (Figure 139).

type uniform letters usually formed mechanically. Type is distinguished from SCRIPT by its unvarying adherence to prescribed FORMAL limits. It can give text materials an anonymous and authoritative feeling. Type also refers to the output of text printing or the

individual character unit or block of a TYPEFACE. Type is the MEDIUM manipulated by typographic artists.

typeface an alphabet and frequently numerical figures and punctuation marks that have been created for printing purposes. A typeface has consistent visual properties. Fenice and Optima are twentieth-century typefaces. Fenice is a SERIF typeface, Optima is SANS SERIF.

This book is published in New Century Schoolbook.

unity the quality of ONENESS. Most AESTHETIC theories refer to unity in concert with VARIETY as a distinguishing characteristic of works of art. Unity results from the consistent application of design principles, singular vision on the part of the artist, REPETITION, and HARMONY within an image. Unity must be balanced with variety to create an image with more than passing interest.

value the dimension of COLOR that describes its lightness or darkness. Value is responsive to the reflectivity of a color. It may be understood as the relative

FIGURE 139 Two-point perspective.

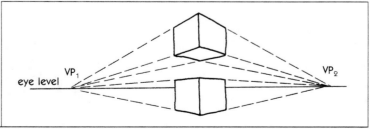

lightness or darkness of a color when seen on a black and white television or in a black and white photograph. The closer a color's value to white, the higher its value. The closer its value to black, the lower the value. High value is light. Low value is dark.

Value is one of the most important visual elements in the organization of an image. The richness of expression in ACHROMATIC media such as black-and-white photography and graphite attests to the expressive power of value. A quick look at the illustrations in this book points out the attention paid to value by artists working with color as well. Although all of the reproductions are in black and white, they manage to convey an enormous amount of information about the full-color originals.

Attention to value is an acquired skill. This can be seen by comparing black and white snapshots to fine photography. One of the things that distinguishes amateur from professional work in photography and other media is the greater sensitivity to value on the part of the trained artist.

The importance of value was further demonstrated in the TV coverage of the 1960 presidential election. The designer of the national election map for one of the major networks had developed a color-coding system to inform the viewers of the graphic flow of the returned votes as they were counted. As one might expect, the colors used in the design contrasted strongly in HUE, but the designer neglected to compare their values. Those watching the election returns on black and white televisions (the vast majority of television sets at that time were black and white) saw nothing but a uniform gray.

value scale a chart showing even steps in VALUE from white to black. MUNSELL quantified value on a scale from 0 to 10, with 0 representing absolute black and 10 representing absolute white (Figure 140).

vanishing point in LINEAR PERSPECTIVE, a point, on or off the page or SUPPORT, where parallel lines understood to be moving away from the viewer into PICTORIAL SPACE converge. See also *one-point perspective; two-point perspective; three-point perspective.*

variations a series of pieces or images, similar to one another in most respects, with a limited range of elements changed from one piece or image to the next. In looking at a group of variations, we are always aware of the theme they have in common. A major source of interest may be the observation of the varied effects of minor changes.

A series of variations is distinguished by how much they have in common with one another, not how different they are.

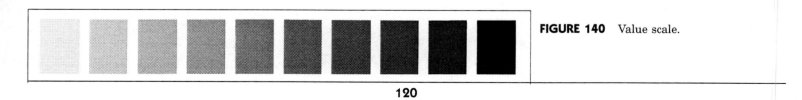

FIGURE 140 Value scale.

variety difference. Variety is needed in works of art to balance those factors creating UNITY. Variety results from the use of unexpected and contrasting visual and conceptual elements. These elements provide variety because of the differences between them and the dominant visual structure. It is necessary to understand the unifying GESTALT of an image in order to appreciate the role of the contrasting elements that create variety.

visionary art art made in response to an individual, often spiritual, vision. Visionary art, such as that by the Reverend Howard Finster, typically explores religious or utopian themes (Figure 141).

volume color the PERCEIVED COLOR of a semitransparent volume. For example, the perceived color of a deep lake is altered by the passage of light through the liquid. A single handful of water from the lake

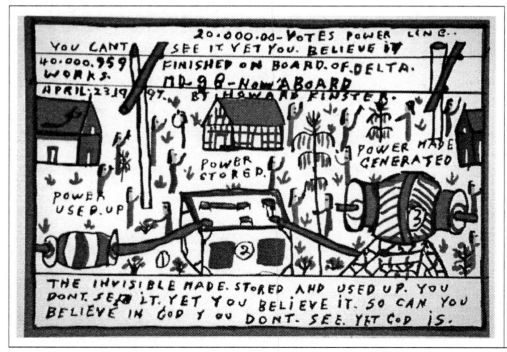

FIGURE 141 Reverend Howard Finster, *Howard Finster's Faith*, 1997, silkscreen, 15″ × 22″. Private collection.

may appear nearly clear, but the entire lake, viewed from a distance, is likely to seem a deep blue.

warm color a color whose HUE is in the area from red to yellow on a COLOR WHEEL (Figure 142). Warm colors tend to advance in PICTORIAL SPACE.

wash a transparent area of pigment covering a broad area of an image.

watercolor a water-soluble paint in which the BINDER is gum arabic, glycerine, and/or honey. See also *gouache*; *transparent watercolor*

FIGURE 142 Warm colors.

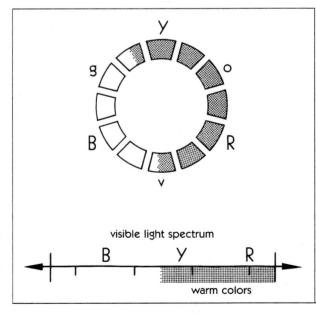

FIGURE 143 Lloyd Wassenaar, *City View #5*, 1995, woodcut, 5″ × 5″. Private Collection.

woodcut a RELIEF printmaking technique in which the image to be printed is carved into the surface grain of a wooden plank. When a softwood is used, the grain may be visible in the finished print, contributing visual TEXTURE and sometimes PATTERN (Figure 143).

FIGURE 144 Charles Sheeler, *Delmonico Building, 1926*, lithograph, ink on paper, 24.7 cm × 17.4 cm. Courtesy of the Fogg Art Museum, Harvard University Art Museums. Gift of Paul J. Sachs. © President and Fellows of Harvard College, Harvard University.

wood engraving a RELIEF printmaking technique in which the image to be painted is created in the end-grain of a finely grained hardwood. This technique enables the production of much finer detail than does WOODCUT.

worm's eye view a point of view in which the scene depicted is shown from an exaggeratedly low vantage point (Figure 144).

xerography the process of making images with photomechanical copying machines. With recent developments in copiers enabling them to print on a wide variety of PAPERS and in COLOR, artists increasingly are exploring the potential of these machines as tools for the making of both unique and multiple editions.

CHAPTER THREE

Exercises and Analysis

Most of your energies in studio classes are devoted to two activities: solving problems and critiquing those solutions. In this chapter you will find suggested strategies for class critique, generic design exercises, and questions to ask yourself about your work and that of others.

CRITIQUES: STRATEGIES AND QUESTIONS

The primary forum for communication in the school setting is the critique. It is here that the opportunity exists to see your work through the eyes of others and to share with them your perceptions of their work. Too often critiques become monologues by instructors. This can be the result of students being interested only in what the instructor has to say, not realizing how much they have to offer to one another.

Involving the class in critiques is a continuing challenge, but it is worth the effort. One of the most important skills to be developed in foundation studio classes is the ability to speak intelligently and productively about one's work. It is essential that students learn to relate to their instructors and colleagues as collaborators and to think of their artifacts as works in progress.

One strategy that we have found effective in developing these skills involves the following elements.

- All work is hung up at the beginning of class.
- The pieces are labeled with numbers so that they can easily be referred to without descriptions such as the "yellow one with a house" or "Jean's piece."
- A "theme" for the critique is presented in the form of a question or directive.
- The students are asked to take anywhere from five to twenty minutes to write down responses to the question or directive in their sketchbooks. In addition, the students are asked to make quick thumbnail sketches of each work presented.

At the end of this process, the critique is ready to begin. This approach yields several benefits. The numbering of the pieces helps to isolate the ego of the artist from the work being discussed. The thumbnail sketches encourage the students to look carefully at every piece that has been

presented. The theme question suggests a framework for looking at the images, and finally, the writing—which is not collected—ensures that each student will have something to say during the discussion that follows. In informal classes, students' conversations during this sketching and writing period may cover much of what is sought in the critique.

The following have been successful themes for critiques.

1. Divide the work into two or three visual categories. Explain which category each piece belongs in and why.

2. Select the piece most similar to your own and describe the similarities and differences. Suggest relative strengths and ways in which either piece could benefit from being more like the other.

3. Invent a title for each piece and explain the appropriateness of the title.

4. On separate sheets of paper, make suggestions of ways to improve each piece. Do not write down your name. (These papers are collected and read aloud by the instructor.)

5. Vote for your favorite piece. The ballots are collected and tallied. (Usually there are clear "winners" and "losers" in this popularity contest. The work is rearranged in order of votes and students are asked to describe qualities that distinguish high vote-receivers from low.)

6. Find as many visual characteristics as you can that are shared by three, but no more than five, of the presented pieces. (As with all of the themes, this is aimed at developing critical observation skills. An effort is made to encourage students to form innovative visual categories in which to place objects.)

7. Finished pieces are assigned randomly to each student with no student receiving his or her own work. Students are asked to present the assigned pieces as if they were filling in for a missing colleague at an important conference. They must, without consulting the artist, explain the intent for the piece, the devices used by the artist to achieve expressive goals, and the work's effectiveness. Negative comments are not permitted, but the presenter might suggest, "We have considered several variations in this proposal including . . ."

8. You are asked to select your favorite piece. Suggest three major changes that might be made in the piece without diminishing its quality. Describe the effects that these changes would have.

EXERCISES

1. Make a detailed OBJECTIVE DRAWING of an ORGANIC object using only LINE (no MODELING or VALUE gradations). The drawing should fill the entire FORMAT, with the BORDER functioning as a window. This drawing will require patience and careful observation. There should be a point-for-point correspondence between each mark on your page and a visual aspect of the object being rendered.

2. Use a CROPPING FRAME to select an interesting COMPOSITION from a small section of an image, object, or scene. The DRAWING created in Exercise 1 may be used as a source. Transfer this pattern, within a clearly delineated BORDER, to your FORMAT. Use pen and ink, graphite, or some other ACHROMATIC medium to MODEL various areas within the piece and create a convincing PICTORIAL SPACE.

3. Design a simple SYMBOL or sign to represent yourself. Consider it your personal TRADEMARK. Your design should

be composed with graphic interactions of SHAPE and should avoid reliance on LINE to define CONTOUR. Pay special attention to POSITIVE and NEGATIVE SHAPE, and FIGURE/GROUND relationships. Render the design in black (india ink, cut paper, paint, etc.) on a white GROUND. Your finished piece should have a broad BORDER.

4. Explore a variety of COLOR contrasts by creating a simple STENCIL. The design from Exercise 3 may be used as a basis for the stencil. Create several dozen paper "tiles" about 1 1/2" square in a variety of colors, seeking as wide a range of HUE, VALUE, and INTENSITY as possible. Carefully apply the chosen design in contrasting color to each of the tiles. Explore contrasts of hue, value, and intensity. Select a number of your tiles and arrange then in a regular GRID with a narrow space between each tile. Use some principle of color interaction to organize the tiles within the grid, for example, high value at the top gradually becoming low value at the bottom. Again, be sure to leave an ample BORDER around the image.

5. This project will involve the interpretation of an existing work of art through a PROCESS of abstraction. Go to the library and find a reproduction of a complex painting completed before 1880 (each student should select a different image). Sources should be limited to older historical sources in an effort to avoid abstracting already highly abstracted images. Paintings are preferred because of their reliance on large areas of VALUE rather than LINE. ABSTRACT the image into a simple black and white value pattern. View the finished works together as a class looking for similarities that may suggest structures for the organization of successful images. Chosen images should be compositionally complex. The main concern of simple images such as portraits is more often with creating likeness than with COMPOSITION and structure.

6. Use a photocopy machine to gather images from a variety of sources, then combine them in a SURREAL COLLAGE. Pay special attention to PICTORIAL SPACE, VALUE relationships, and ATMOSPHERIC PERSPECTIVE. Endeavor to make your piece both fantastic and believable. Photocopy the finished piece and investigate the use of SPATIAL COLOR to enhance the illusion of space. (Note: It may be possible to photocopy the finished image onto quality art PAPER.)

7. Explore NORMAL VALUE and the confusion of VALUE with INTENSITY by finding a full-color reproduction of a complex image containing a broad range of HUES, INTENSITIES, and values. Reproduce the image ACHROMATICALLY in a full range of VALUES, matching perfectly the value relationships in the original. Test the finished product by comparing it to the source using a black and white photograph. This is a very challenging exercise.

8. Experiment with the BEZOLD EFFECT by working from a CROPPED portion of a photographic image as a source. Use cyan, magenta, and yellow inks with a fine point pen to mimic PROCESS COLOR.

9. Explore the dynamics of GROUPING by creating a single image with multiple REPETITIONS of a single MOTIF in a variety of rhythms. Treat the variety of rhythms with a range of grouping devices.

10. Investigate the evocative qualities of NARRATIVE and ALLEGORICAL art by creating a meaningful image using only NONOBJECTIVE (simple GEOMETRIC and/or ORGANIC) IMAGERY.

11. Go to the library and find a reproduction of a complex PAINTING completed before 1880. Make a group of compositional STUDIES, paying special attention to PICTORIAL SPACE, VALUE, COLOR HARMONIES, placement of objects, and LINE OF SIGHT. Develop a COMPOSITION of your own,

either REPRESENTATIONAL or NONOBJECTIVE, that shares the same underlying structure as this external source.

12. Develop an image in which the FORMAT is broken into at least five subformats, pictures within a picture. Pay attention to the composition of each individual "frame" as well as to the page as a whole. In order to appreciate a piece, the viewer should pay attention to each individual image as well as the whole. Possible frameworks for this exercise are the illustration of a NARRATIVE, a META-MORPHOSIS, or an activity or PROCESS. Good sources for compositional ideas include POLYPTYCHS, altarpiece paintings, instruction manuals, and action comic books.

13. Select a small portion of an enigmatic and imagery-laden book to illustrate. One example that works very well for this is the *I Ching or Book of Changes* (Wilhelm/Baynes, Bollingen Series XIX, Princeton University Press).

14. Establish a careful record of some event or activity over time. A detailed time-log of a two-week period in an individual's life works well. Develop a "code" or "key" for transferring the information from the written record to a graphic image. Students design the code, but the appearance of the finished work is determined by the record to which the code is applied. If the image is unsatisfactory, students must change the code rather than the data. The code should be applicable to a variety of records and should not immediately reveal the meaning of the finished image. The goal of this exercise is to create images that appear to be "information laden"—which will be recognized immediately as having CONTENT, even if the meaning is unclear. Good sources for ideas for the code include scientific charts and graphs, maps, demographic charts, weather maps, astrological charts, and foreign alphabets. The more personally relevant and detailed the information, the more effective the PROCESS and the finished piece.

15. Explore an idea in depth by making at least ten VARIATIONS on a response to a single challenge. The variations should be distinguished by their similarity and their focused exploration of the effect of changing a specific detail in each piece.

ANALYSIS: TWENTY QUESTIONS

The discussion provided earlier in this book of the creative process pointed out the key role of analysis in the cycle of creative problem solving. It is useful to pause in your exercises, step back from your work, and consider your efforts. This same analysis can serve you when looking at work by your colleagues or even when examining art in museums. We present here a by-no-means conclusive list of questions to ask when analyzing a work of art.

1. What was the artist or designer trying to accomplish? How did he or she define the problem and what were his or her goals?

2. Do we as viewers break the piece down into parts for understanding? If so, how are the parts grouped—by similarity, proximity, color, material, direction, gesture, or other means? Do the groupings overlap? How?

3. Are some elements or parts of the image more important than others? Which ones?

4. Could any elements or parts of the piece be moved or deleted without drastically altering its character? If so, how many, which ones, and why?

5. If you were to do a series of variations on this piece, what form would they take? Which elements would you retain and which would you modify?

6. Are the proportional relationships within the piece appropriate? How would the piece be altered if they were changed or distorted?

7. Is the composition of the piece appropriate? How does the image relate to its format? What would it be like in a different format?

8. Is there a good balance between craft and concept? Does the quality and care of its making and materials contribute to or distract from the effectiveness of the image?

9. Is the piece surprising in any way?

10. How would your relationship with the piece change if it were turned on its side or upside down?

11. What is the smallest possible change that would significantly alter the character of the image?

12. Does the image convey a sense of control? Are there any elements in the work that appear to have been accidents? Are they successfully incorporated into the image?

13. How would the piece be changed if rendered in a different medium or at a different scale?

14. Are there any motifs in the image from other works by the artist? Do they work to the benefit or detriment of the piece?

15. Are there any aspects of the piece that remind you of the work of another artist? Do they contribute to the effectiveness of the piece?

16. To what extent does the image allow for a variety of interpretations? Does this openness dilute the strength of the work or increase its universality?

17. What would an image that was the formal or conceptual opposite of this piece look like?

18. Does the work evoke any emotional response? How?

19. Does the work suggest or reveal anything about the artist as a person or the artist's involvement in the making of the work? What?

20. Does the image have any narrative content? Does it tell a story or make a statement? What and how?

Index of Artists' Names